Koo Jeong A

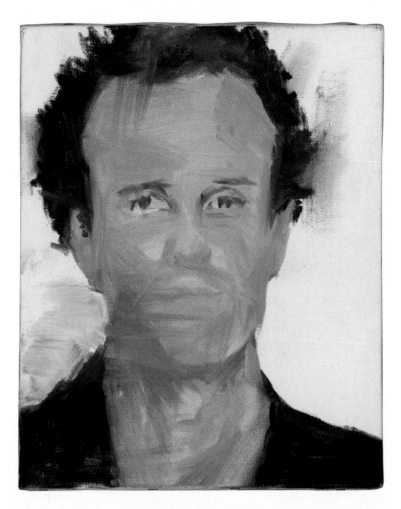

Gerhard Richter

8-10-15

Giorgio Griffa

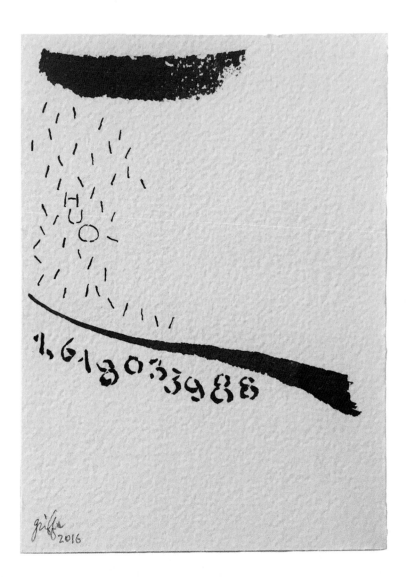

He was just here—

I saw him only a second ago—

We were talking just now, I think he went to a meeting with that architect...

He said he'd be at my studio at 2 o'clock—

He just now turned the corner—

He was getting into a taxi—

Jimmie Durham

He just got out
of a taxi -- -

He was with those
guys in the hallway --

He said he was going
to Paris today --

We met in London
yesterday -- -

I saw him in Shanghai
three days ago -- -

He was coming from
new Delhi -- -

He had been to Beirut
just before ---

He had these two big
bags of books ---

He asked if I had fifteen
minutes this evening ---

He had some large video
cameras and some other gear -

He said he had to be
in Capetown - - -

He has to curate the
show in Berlin - - -

He will curate the show
in Frankfort - - -

He's going to curate
the show in Belfast - - -

He is going to interview
Joseph - - -

He just interviewed
Elisa ...

He just finished his
new book of interviews -

He wants me to meet
that geologist ---

He is working on a project
with the architect and
that composer ---

He was just here --

a Portrait of

Hans Ulrich Obrist

by Jimmie Durham
2016

This painting was made possible by a printer. I painted a portrait of Hans Ulrich Obrist, and printed it onto a page from the book *Project Japan: Metabolism Talks...* (2011) (which features the dialogues between Obrist, architect Rem Koolhaas, and members of the Japanese Metabolist school, an important architectural movement in Japan after WWII and also the first global architectural movement initiated in Asia). The idea for this set originated in my interest in the "stacked paintings" tactic often employed in Orson Welles's films, in which two scenes overlap, slowly fading and emerging simultaneously.

Cui Jie

1976 KIKUTAKE: ABU DHABI FLOATING HOTEL 1976菊竹清训：阿布扎比漂浮酒店

Last resort 最后的娱乐场

A year after the Aquapolis, Kikutake is invited to a competition in Abu Dhabi, which has a growing appetite for luxury and leisure. Collaborating with Mitsui Ocean Development & Engineering, he designs a crescent-shaped hotel for Abu Dhabi's waterfront that floats independently of its surrounding courtyard, so that it can rotate 360 degrees every 8–10 hours. Parts above the water level would be prefabricated by shipbuilders and towed to the site by boats. Rooms are plugged in the semicylindrical structure—a vertical ground, like Kikutake's earliest tower proposals.[15]

水城一年之后，菊竹清训被邀请参加豪华与休闲胃口逐步增长的阿布扎比的一次竞标。他与三井海洋开发与工程公司合作，为阿布扎比的海滨设计了一个独立漂浮于周边的庭院中的月牙型酒店，它每8-10小时会旋转360度。水面以上的部分，由造船厂加工预制，并通过船运送到基地上加以组装。客房插入到半圆筒形的结构中——垂直的地面，就像菊竹清训最早的塔的设想那样。

Courtyard includes a waterfall, woods, and swimming pool.
庭院包括瀑布、树木、和游泳池。

K. Kikutake
+1/1/15

Hans Ulrich Obrist : But to continue with the politicial dimension, many of the Metabolist members referred to Marxist teachers. Was there a kind of Marxist background in Japan?

Rotation, which seems implausible, takes place "with a simple system," according to Kikutake: the circular inner courtyard and hotel move together while the surrounding square platform remains static.

旋转，这似乎令人难以置信的动态。"通过一个简单的系统"就得以实现，据菊竹清训所说：庭院内部的椭环系统和酒店一起移动，而周围的方形平台则保持不变。

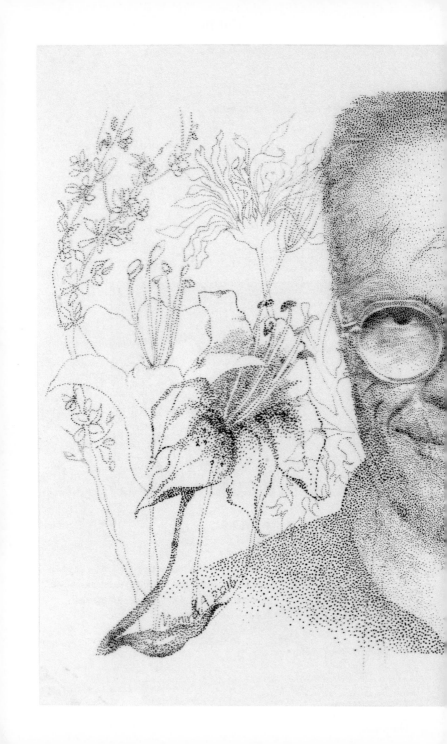

Monir Shahroudy Farmanfarmaian

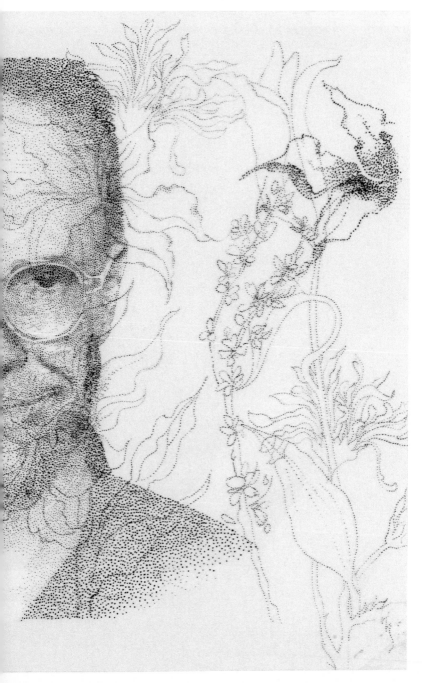

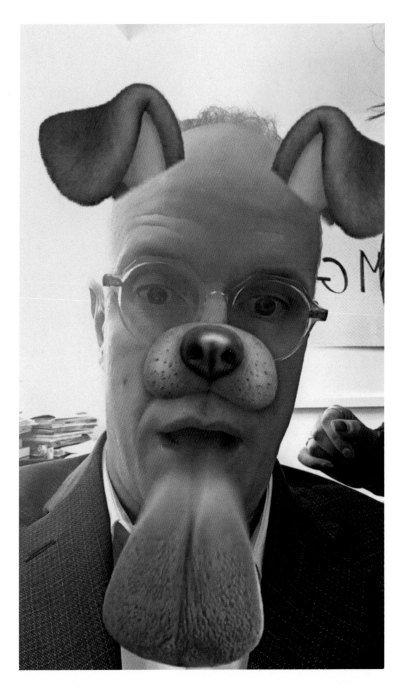

Torbjørn Rødland

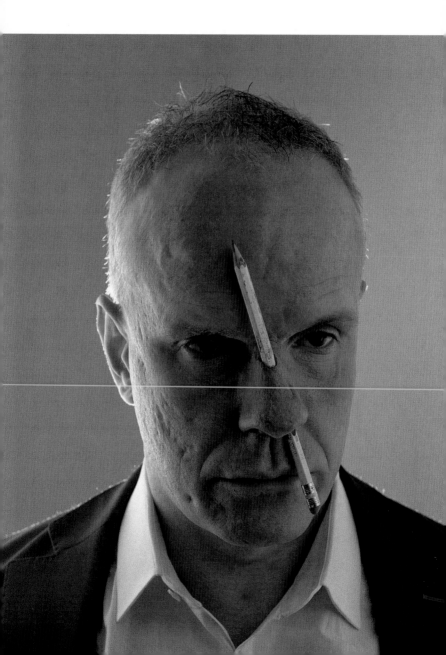

An Exhibition Always Hides Another Exhibition
Texts on Hans Ulrich Obrist

Edited by April Lamm
Published by Sternberg Press

Table of Contents

We live in funny times. Over-the-top, anything-but-intelligible is the new norm. So what I am about to say won't sound funny or over-the-top in any sense at all:

Hans Ulrich Obrist is a guru of the art world. A guru deeply engaged in the proxy warfare of exhibition making, of making sense in a datascape of unsense. He is a hacker mental space, a data compressor! There are many who know just his name or just his initials, HUO. And while that may become an acronym one day for Hard-drive Unraveling Operations, or Hyperlink User Opacity, this book is here to tell you more about *that guy*, HUO.

Hans Ulrich Obrist has never curated documenta or the Venice Biennale—the two biggies of the art world. And yet, he is big. Bigger than any institution. He is a perambulatory art-production factory with many benevolent arms! Good-will tentacles! A strollologist, as sociologist Lucius Burckhardt might describe him. He brings scientists, architects, herbologists, and philosophers into the fold of artists young and old.

What does it mean to be HUO? What does it mean to be a curator? Is there anything less interesting to me (or you?) than selecting artists for exhibitions? In an era of, let's say, "boutique" art shows, the issue seems about as relevant as Diet Coke.

But if anything, Hans is the Real Thing. Hans is Coca-Cola. Hans is *it*.

His choices never bore me. He's not just a maker of exhibitions, he's a maker of the *Gedankenausstellung*: the tickling "thought exhibition" (as described by Bruno Latour in this book). His exhibitions are never transparent, never hole stoppers to fill a quota. His choices are relevant; they meet a moment. They stimulate us more than Hans's legendary twenty-one espressos a day ever could. A super-food brain supplier—that's what Hans is. He keeps us here in the art world, on our toes, anticipating, questioning, ever critical. And as Carsten Höller once famously said— not asked—"What better world is there?"

In this book you'll find both personal, anecdotal remarks on HUO's character, and republished texts that give context to the questions that frame the book: "Who is HUO?" and "What does HUO do?" More so, "What has he done?" If the art world were to seek out a supreme leader who was benevolent, kind, and fair, HUO would be it. Those who are looking for role models will find this book insightful for all the avenues it takes you down. A small sample of what you'll find in these pages: Ed Atkins gives us his jittery take on what it feels like to meet the art pope, his "rookie flush." Alan Pauls explains how it's possible to make being a walkie-talkie your j.o.b., an interviewer nonpareil—and the maieutic (look it up) factor involved. In his *New Yorker* exposé, D. T. Max throws a few curve balls, at one point telling us how Alighiero Boetti actually complained about how slow HUO talked. Michael Diers gives us the historical background on the art of the interview (to date, there are some eight hundred published interviews with HUO), while Douglas Coupland tells us why interviews can suck. Bruce Altshuler gives us the prehistory of his DIY-spirit "do it" project (where the artists supply instructions rather than finished artworks), and, and, and ... I could go on forever but you might fall asleep before you have the chance to read my betters. Daniel Birnbaum and Joseph Grigely perhaps know HUO better than HUO knows himself, and finally, Stefano Boeri tells us what HUO is not.

HUO remains an entity that we'd like to see more of out there. More HUO, more *huo-manity*. Dip into the smorgasbord of words here describing this man on a mission to change the world and you'll know what I mean.

April Lamm
Berlin, June 2018

Hans Ulrich Obrist's every undertaking is a journey.
Here, it is a journey into his own night, that of his memories, of his life.

Since his childhood—that of a solitary, gifted boy—
he has looked to go further, with the Swiss mountains as
the first horizon for him to cross. And go further he has.

Today he is well known on several fronts: "I'm in the
middle of things, but at the center of nothing." From one
thing to the next, moving but never stopping.

We discover that this most contemporary of figures,
always so close to this or that event, is nonetheless in
a constant transcendence, always in some higher place
beyond the one at hand. We realize that the interviews
he has tirelessly conducted are more than interesting
exchanges and that, beyond their immediate interest in
the here and now, they constitute a broader and apparently unending "oral history of art."

We also come to realize that the exhibitions he has
organized over the years—more than opportunities for
research and discovery—can be considered as mise-en-
scènes, with each one a comprehensive work of art made
of other works of art, and each one an event in itself. For
Hans Ulrich, curating begins as a journey, a voyage from
one work to the next, one artist to the next, and always
with a view to creating a mystery.

When he says, "I am not an artist," we cannot help but
wonder, "Is that really true?" As far as I'm concerned, at this
moment in time, when definitions are becoming ever more
broad, I would say that Hans Ulrich is indeed an artist,
and an important one at that. At the very least, he has the
temperament for it. His material of choice is not paint nor
sound nor any other such medium, but rather, as he himself
says, his eye; hence this feverishness that possesses him, and
which only abates, temporarily, when he discovers another
being just as feverish, just as unstable: an artist, an initiate.

There is a thinker in Hans Ulrich, as there is in
every artist; did Leonardo da Vinci not say it best when

7

he suggested that painting was, above all, *una cosa mentale?* His thought hinges on a profound inquietude, since the truth that he seeks is itself mobile and shifting: he must attain a similar speed and learn to follow its movements before even beginning to think it through.

"Art, for me, is to change what we expect from art." Art must therefore change—and changing it is; its meaning, what it brings us, must be in a state of flux too. Art is an exercise in the navigation of troubled waters, and one that always leads toward unknown oceans. This is why his quest is obsessive, his world fantastic.

The interview, this dialogue reveals what it is that Hans Ulrich seeks in those he finds, in their art, in their work: a direction, a path, a path toward a possibility of living—what he calls hope. Artists gather and redirect, then, the forces of life, rallying them against the all too powerful forces of destruction, of annihilation.

Perhaps he does not quite realize the extent to which he resembles these artists, or how often he is the one who opens up the pathways for them. Because he is not in search of lost time, but rather of present time: a present, that is, turned toward the future. "The future is art's interior." Thus his métier becomes the creation of an artwork that is invisible yet recognizable, a work forever in progress.

How does this present—this present turned squarely toward the future, this present that in its unceasing transformations *becomes* the future—reveal itself at its most effective moment, if not by way of epiphanies? We know that Hans Ulrich, or the child that is and has always been within him, is on a permanent quest for epiphanies: those moments when appearances are traversed by their own secret, a secret which traverses us in turn, and leaves us amazed.

These moments, explosive as they may seem, are in fact meditations, and for Hans Ulrich they are meditations on the human condition. With each exhibition he seems to say, Look at these works, close your eyes, open them once again, and you will rediscover the state of the world, and your own state of being.

The energy for this enterprise comes from the fact that Hans Ulrich has what we call a soul. But he is also endowed with that rarest of things: "I think that generosity is my medium."

Yes, if Hans Ulrich uses art to dedicate himself to the common good, it is because he is on the side of the angels.

Etel Adnan
Paris, August 2017

Hyperbole

Ed Atkins

Hanging out with HUO can be like having a protracted
seizure. At least, the first few times. Or like submitting
to a drug trial or something. It's quite a shock how profuse
the information, how lunging the discourse, how insatiable
the appetite. The first time I met with HUO I was nervous,
ill-prepared and overburdened with a laptop, books,
a rehearsed spiel—"whatever" props. I had scant idea
of what to expect, save an ambient sense of HUO's superla-
tive art clout and his near-total ubiquity. I had, I suppose,
an idea of what it might mean to be meeting with him.
We were to meet at his office in Kensington, something
of a schlep from the Serpentine Gallery, which is where
I'd headed to first, presumptuously, before looking over
our email conversation again and realizing my error.
Luckily, I'd arrived at the Serpentine ludicrously early,
so was only slightly out of breath and clammy with sweat
by the time I got to his office. He wasn't there, but a kindly
assistant offered me a seat and a coffee and told me he was
on his way. Some interminable time passed in silence, me
tremulously sipping the coffee, foolishly trying to cool it.
Then HUO appeared suddenly through the door, with a
rapt bustle, mid-conversation with one or two smart-
phones cradled on his shoulder and in one or two or three
languages. I remember he started talking about flu jabs,
and I wasn't really sure if he was talking to me or to
whoever was on the phone. Something about vitamins that
segued into exercise, jogging, routine, coffee, Balzac,
sleep, time, clocks, Anri Sala, Christian Marclay (whom
I'd just finished working for), etc. It's a dance of associative
transportation—often performed while moving, literally—
that I've become very happily familiar with. A certain
rhythm, staccato, corroborative, nursed with smiles and
crazed blurts of surprise (*"Oh em jee!"* "So urgent!" "I'm
fainting!"); the oddest harmonies form, right there. It's
certainly become a terrific form of accord with HUO.
Something that, subsequently, constitutes the form of our
meetings: a gorgeously deranged, highly propositional
schematic for the future that, more often than not, is
mapped on notepads and relayed by irruptive phone calls

and recorded on multiple dictaphones by HUO himself. Whereas now I will merrily subscribe to the theater of it, it was all I could do to simply burble affirmative sounds at that first meeting.

So we move into his office, every surface of which is groaning with books, papers, and items discarded with the urgency of a person ravenous for whatever is next, and I sit down at his desk, across from him. He fishes those twin dictaphones from his bag, presses RECORD, and starts asking me fantastical questions, each loaded with generosity, hyperbole—a searching, rarified consensus. I remember answering with mounting giddiness, learning the tenor of this exchange, the terms of the engagement—how to respond with a matching rhapsody, how to enjoy it. Throughout, HUO is busy, with everything: writing, sketching, doodling, recording; leaping up from his chair to locate a cited book from a teetering pile; messaging other people, presumably about something entirely different; phoning an enormously influential person I'd mentioned with admiration and proffering the phone to me. On this occasion I think he called Frederic Tuten. A glimpse into the vast network. At a pressing clip, he introduces Frederic to the idea of me, saying how incredibly urgent it is we meet. Then he thrusts the phone at me and I say a timid "Hello." Frederic, or whoever it is, speaks politely—a man way better schooled in this delirious method than me. And I have no idea what to say, no idea how to take this opportunity and run with it, how to muster sufficient presumptuousness to ask ... *anything*. I simply say that I'm a huge fan and that it's lovely to kind of meet him and that I hope to meet him in some other reality sometime and goodbye. I pass the Blackberry or iPhone back to HUO, who signs off with Frederic in adulation and love (always love), and we, HUO and I, return to our dance. More books are suggested, a fresh tape in one of the dictaphones, and then, suddenly, we have to move. HUO is scheduled to attend an opening at Iniva in Shoreditch so we must continue our conversation in a taxi, with a stop to pick up Julia Peyton-Jones. She's ready and waiting and

climbs into the cab and we're introduced and I smile, narcotized by the proceedings; Julia returns the smile knowingly, recognizing my light-headed panic, my rookie flush. So we speed through the London twilight in the back of a black cab and I start showing everyone manic edits of my already manic videos on my laptop, tendered like salver, while HUO videos everything on his iPhone, gushing about how amazing this all is and how all meetings *from now on* will be held in the back of taxis. Despite, or because of, the puffery, I entirely agree. And the videos kind of mirror the jump-cut reality that's unraveling with hysterical pace, breathlessness, ebullient impatience. I'm warming to it all: flung about on the back seat, laughing, showing my videos, starring in an HUO special—and things are weirdly lucid. There's a bit where Julia gets queasy (the videos strobe and howl, the suspension is truly fucked) and we pull over so she can lean out the door and breathe a little. And before long we arrive at Iniva, where I feel like art royalty for a moment, exiting a cab with these two. I manage a goodbye before they're diverted by more important creatures and I slope off, heart pounding, to get a drink or a shower or something. I'm grinning too, distracted, high.

Nowadays, I'm more familiar with the tempo of it all—and I'm more capable of contributing to proceedings beyond just keeping my head above water. We've established pseudo-routines of our own—modes of address we've maybe caught off one another, an understanding that's borne of that urgent kind of emesis related above but which I can now savor. At each of our "summits" something vital is gleaned, some tentative idea is given flight. And at the end I'll contribute some tragic drawing or bon mot to his already untold number Post-it note project, and then, for some reason, I'll stick the Post-it to bread or toast or whatever, and eat it. Which feels like a pretty decent, sensational, performed representation of what's been going on. Or at least a fine bit of obscure punctuation before the next meeting. "Hurricane Ed," he calls me in emails. Inaccurately but without irony, fantastically.

Prologue

Hans Ulrich Obrist has been accumulating a veritable
oral iceberg of interviews since the mid-1980s, when he
was studying social sciences, met Alighiero Boetti, and
realized that nothing interested him more than talking
with artists. Undoubtedly, this relational passion (almost
stronger than any devotion for an object known as a
"work of art") was the birth of Obrist the star curator,
the one-man band, who since the early nineties (he was
twenty-three years old when he converted his kitchen into
a gallery and held his first vernissage) has organized
more than one hundred and fifty exhibitions throughout
the world to date, added his signature to hundreds of
catalogues and specialized art magazines, and has for
a couple of years now been the artistic director of exhibi-
tions and programs and head of international projects
at the Serpentine Galleries in London. In Obrist's case,
curatorship is perhaps merely the continuation of conver-
sation by other means. The network of works, practices,
experiences, and artists creates a kind of global, 3-D
version of the true scenario that for Obrist seems to
condense the experience of contemporary art (or at least
his favorite *performance*): the scenario of *interlocution*.

Obrist knows no peace. Ubiquitous, hyperactive—
he lives from airport to airport, international fairs,
conferences, openings, competitions—a little like the
elegant, relaxed version of that always identical Wally
who, in a game surprisingly in sync with our times, asks
the viewer to find him in the most absurd contexts of
the present. And if, like Wally, Obrist never changes,
is always recognizable, it's because there is something
he never stops doing, at ten thousand meters in the air,
in a tunnel under the sea, a taxi stuck in a traffic jam,
or on the seventieth floor of an intelligent skyscraper:
conversing with artists. This is how many of his inter-
views are carried out: in transit, in the ephemeral set-
tings offered by the theater of contemporary artistic life,
and are imprinted with the mark of instability, anxiety,
and the lack of permanence that often permeates the
works and practices of the artists he meets to talk to.

Obrist always seems to be somewhere *else*, and always, at the very least, in two place at once—as if instead of one there were ten, one hundred, a whole host of tiny Obrists in their light-colored jackets and shirts, all of them impeccable, as if recently laundered, spreading through the world on a mission to activate some sleeping or unexplored cell of the artistic experience, camera in hand, recorder switched on, mobile phone on red alert. The only permanent thing is the conversation: the only *continuous* place in a map that draws its logic and sustenance from discontinuity. In fact, Obrist's conversational projects are the most long-lived, the ones that traverse every period unscathed: The interview project that includes more than two thousand hours of recorded conversations with artists, writers, musicians, philosophers, scientists, and engineers is a sort of constantly expanding oral archive that is open to all kinds of reconfigurations. Or the *Conversation Series,* the collection of twenty-eight books of interviews, each devoted to a single artist, that Obrist is publishing with the editor Walther König. In addition, events like his famous Marathons, which—from Stuttgart to Beijing, taking in London on the way—boast fifty interviews in one day and are already a classic of long-form conversational *performance.*

Of course Obrist did not invent gunpowder. The genre of the artist conversation is as old as Vasari's *Lives of the Most Eminent Painters, Sculptors, and Architects* (1550). The word "interview" (or its archaic shadow) already figures in *Entretiens sur les vies et sur les ouvrages des plus excellens peintres anciens et modernes* (1666–88), by André Félibien, Controller General of Roads and Bridges. Obrist himself cites being inspired by one of the essential artistic tête-à-têtes of the twentieth century: the conversations between David Sylvester and Francis Bacon. He could also have mentioned those between Pierre Cabanne and Marcel Duchamp, or some literary examples in the same genre, more eccentric but equally influential, such as *Conversations with Kafka* (1968) by Gustav Janouch or *Walks with Walser* (1957) by Carl Seelig (who, in turn,

refers back to the conversations between Goethe and
Johann Peter Eckermann and those of Samuel Johnson
with his faithful amanuensis James Boswell). And yet
the differences are obvious: Sylvester chose to interview
Bacon in order to stay with him and go back to him on
three occasions, in an attempt to exhaust the subject in
a way that would never occur to Obrist—even when he
returns to the people he interviews. Janouch and Kafka
talked as if they had all the time in the world, all the time
that Seelig and Robert Walser possibly did have, if by
"world" we mean the psychiatric clinic near Herisau,
Switzerland, in which Walser was cooped up for the last
twenty-three years of his life.

Obrist, on the other hand, usually talks to artists
in a range of contexts that are casual or vaguely urgent:
between flights, between two appointments, between
social engagements. His interviewees are rarely in their
studios, never at home or in their galleries, or anywhere
worthy of being called "their own." They are always
exposed to life in some kind of storm, they are coming
from somewhere or going somewhere else, they have
something pending that's been kept waiting too long.
This external factor—this strange, *flexible* urgency, so
unlike the enviably relaxed climate that usually governs
conversations—is not the only characteristic that makes
Obrist's exchanges such a hyper-contemporary phenom-
enon. Before reaching the book stage, the last but not
necessarily most important form they attain, Obrist's
conversations appear and circulate through a haphazard
promiscuity of newspapers, magazines, and *online* publi-
cations, and are reproduced in the media, in different
countries and languages. On the way, they undergo all
kinds of alterations, reversions, editions, and additions,
in a *remix* destiny that is so impersonal, so linked to the
appropriationist logic of the media that it becomes all but
impossible to decide which is the original text (if there is
one), which language it was written or spoken in (if there
is one: Obrist's dialogues tend to be interlinguistic), and
when it was published for the first time.

Possibly one of Obrist's most noteworthy and para-
doxical merits is that he has managed to revitalize the
genre of conversations with artists in the eyes of a com-
munity, perhaps a generation, that had every excuse to
look down on or ignore it and every reason to disbelieve
in the concept of art and the artist that it presupposes.
If Obrist's conversations are 100 percent contemporary,
this is due above all to the flagrant, even jovial, almost
hedonistic way in which they dramatize the eclipse of
the configuration *critic/critical discourse* (which dominated
until the eighties), its replacement by the configuration
curator/conversation (that has prevailed since the nineties),
and the surprisingly mild displacement of the *work*
(as object of analysis, criticism, reflection, and object
endowed with a certain autonomy, at least with regard
to its creator) by the figure (personality, life, intention)
of the *artist*, an object of interest, of complicity, and even
of mystification, inasmuch as he has once again become
the person who has the last word concerning his work.
Consciously or unconsciously, many of the delights
produced by the interviews feed the anger or nostalgia
of those ejected. The cooperative nature of the conversa-
tion—its almost casual tone, the ease with which it moves
from gossip to an artistic or political diagnosis, from
private triviality to the discussion of ambitious aesthetic
programs or complex social problems, the lack of dis-
tance between the interlocutors, the way all polemical
factors are placed in parenthesis—everything that makes
these interviews an exercise in happy, inspired discursive
digression, and occasionally as artistic as the works they
are alluding to, is what at the same time foregrounds the
radical eclipse of the values that until recently governed
the art game and decided the prestige or otherwise of its
players: critical distance, opposition, controversy, etc.

And yet if there is one thing that is not absent from
these interviews, it is tonicity. However, it is the kind of
tonicity most questioned by critical thinking: a *fluid*
tonicity, capable of boldly affirming, discriminating,
cutting, clashing, disagreeing—everything that muscular

critical culture arrogated for itself—the privilege of doing
without the need to shock, become tense, raise one's voice,
or reduce the world to that skeleton of binary oppositions
without which the culture of criticism usually finds itself
lost. Obrist is perceptive and shrewd, but not amnesic,
and the good humor, happiness, and combination of
enthusiasm and curiosity his interviews display are never
confused with those exercises of tabula rasa to which
we have become accustomed—due to the arrogance of a
discourse about art that only trusts its own self-absorption
in the present. It is no coincidence that one of the ques-
tions that reappears time and again is the question of
utopia: a discarded idea if ever there was one, an easy
target for all contemporary sarcasm. It is a question
Obrist dusts off with the patience of an ant. And with
artists who, a priori, would seem most resistant to its
charms (Jeff Koons, for example), the question is never
celebrated as a *vintage ideologeme* but—supreme irony—
with a criterion that is 100 percent pragmatic, making
it operate in the most hostile contexts and putting its
capacity for power to the test. In this sense, Obrist's
conversational practice has little in common with the
liquefaction of hardcore criticism and much more with
some of its most eccentric, most fertile forms of survival:
for example, the television interviews with Alexander
Kluge, or the extraordinary conversational moments
of films such as *News from Ideological Antiquity: Marx/
Eisenstein/Capital* (2008)—Kluge's "adaptation" of Marx's
Capital, a real marathonic essay (eight hours) in which
the figure of the critic, parodying the communicational
imperative of the time, becomes an interrogation machine,
a discursive *punchball,* intellectual *partenaire,* curator
of others' thoughts, magnet, attractor, a host for undesir-
able foreigners.

From the outset, the *casting* of Obrist's interviewees
offers a rich variety of stimuli. Obrist, as they say, will
talk to anyone: icons of Conceptual art from the sixties
and seventies, militants of the nineties, *hardcore* European
painters, esoteric *performers, divas* of sexual provocation,

entrepreneurs of the art market, stern conceptualists, environmental activists, lawless sculptors, champions of memory etc. This does not mean that Obrist has the same regard for all artists, or that they appeal to him in the same way, or are equally pertinent in the landscape of contemporary art that he builds. What it does mean is that they are all interesting, they all have something to say, they are all relevant as regards *communication*—terms that are far from superfluous nowadays, since it is here that the current *value* of an artist is assessed. If Obrist has any function, it is that of being there and listening to them, almost as if he had not so much a human as a mechanical disposition, somewhat similar to the recording machine that Warhol (the Warhol of the *Diaries* and *Time Capsules*, another of Obrist's precursors) always dreamed of being.

But Obrist is human, perhaps all too human, and possesses what only the great conversationalists have: listening. Listening to be in tune with and seize and transcribe the grain of his interviewees' voices—their expressive or argumentative cadence, the double or triple levels they conceal when they become laconic or eloquent—and often to transcribe them literally, even at the risk of falling into untidiness, repetitiveness, or anacoluthon (the *karma* of ethnographer-interviewers, and also of their translators). But also and above all, the ability to hear the progress of the conversation situation, the conversation event, and to pick up on all that is lurking in their silences, all that it can still offer, the directions it can take, the inflections that could lighten it (when it is becoming too serious) or make it more dense (when it risks evaporating). Obrist also has a shrewdness that allows him to think of his own place in the situation and to choose which of the masks he keeps hidden in his wardrobe—Obrist the organizer, the critic, the researcher, the back-room gallery assistant, the fund-raiser, the artistic director, the most frequent frequent flier—to adopt according to the moment of the conversation, the mood of the interviewee or the direction the interview

is going. And here Obrist is both perverse and polymorphous. Although he swears he does the interviews without a script, simply relying on a series of random questions he jots down on a piece of paper, he always knows when to make an association, when to expound, when to pull a fact from his top hat—the antecedent or example that will lead the conversation in another direction and revitalize it—when to display all his capital as a critic-curator and when to keep it quiet, under what circumstances to play the role of astonished fan or erudite know-it-all, of exegete, confidant, accomplice. Enthusiasm and curiosity—there's no denying that the formula, especially when applied to Obrist's style that is at once forward and impetuous, is far removed from the consensual protocols of criticism. Critics are cold, clinical, and only get heated when they want to make a stand and take up their cudgels, two imperatives that Obrist, with his pluralist stance and formidable range of maneuver, appears to ignore with astonishing nonchalance. To these two qualities we should add a third: *proximity*, which is the sort of relationship Obrist usually enjoys with his interviewees. It is obvious that he has a prior link with Philippe Parreno, Marina Abramović, or Rirkrit Tiravanija, an often generational complicity that is notably absent from his relation with Louise Bourgeois or Gerhard Richter. But Obrist the nosy questioner wants to be the same with everyone; out of all of an artist's possible *others* he wants to be the *closest*, a neighbor, a kind of wise caretaker, exhaustive but in no way indulgent, with whom the artist can relax but above all see him or herself reflected, and surprise himself by saying things he did not expect to say, or realize something, or remember, or lie, or contradict himself, or simply discover himself thinking. (Susan Sontag, an inveterate conversationalist, used to say she conversed to find out what she thought.)

It may be that the maieutic factor does not completely cancel out the proximity factor; it may also even be that in Obrist's case it's one of its most pleasing fruits. But what undermines it is a collateral effect that is quite

common in the formula of enthusiasm plus curiosity: the *groupie* danger. (A question in passing: Just as the curator ousted the critic, when will the groupie—that taliban of interest created by the paradise of accessibility of the web—oust the curator and the spectator, the reader, the *amateur* of art or anything else?) Obrist might flirt with the attitude of a groupie: he even quotes it on reconstructing the primal scene of his encounter with the art world: "In 1986 I was eighteen and Alighiero Boetti told me I could dedicate my life to this. I really believed that artists were the most important people on the planet, and I wanted to help them and be useful to them." But more than a fan, with his compulsions, obsessions, and monomania, the character that Obrist represents when he intercepts artists is that of the student, with his eternal youth, his restless energy, and his eager intellectual virginity: someone who is less pleased with the tasks already completed than those he still has to do, someone with a thirst, and, in more than one sense, a romantic. It's not for nothing that the other recurring question throughout these conversations involves never-completed projects. The reverse of the question about utopia, the one concerning unfinished projects is romantic because it revives a very eighteenth-century passion: a passion for ruins. But here again, Obrist does not visit ruins like a pilgrim visiting a shrine. He returns to them with the delight of an archaeologist who has not slept a wink all night, rubbing his hands, already savoring the rough, slightly singed jewel awaiting him in the rubble: not the past—no, never the past—but the surprising forms of the future.

Sophia Al-Maria

"We will need to invite a delegation of babies."*

* Once HUO and I were called upon to help organize a futurological congress. A typical list of techno-optimists, science-fiction authors, and R&D think-tank types were proffered. Hans Ulrich rejected these usual suspects and instead declared that it would be more worthwhile to converse about the future with the abovementioned demographic. It is my opinion that he was absolutely correct.

The Art of Conversation: The Curator Who Talked His Way to the Top

D. T. Max

Hans Ulrich Obrist is a curator at the Serpentine, a gallery in London's Kensington Gardens that was once a teahouse and is now firmly established as a center for contemporary art. A few years ago, *ArtReview* named him the most powerful figure in the field, but Obrist, a forty-six-year-old Swiss, seems less to stand atop the art world than to race around, up, over, and through it. On weekdays, he works at the Serpentine offices; there are meetings over budgets and fund-raising, and Obrist, with his fellow director, Julia Peyton-Jones, selects artists to exhibit and helps them shape their shows. When I visited him in London in late August 2014, two exhibitions that he had organized were up: *512 Hours*, a "durational performance" piece by Marina Abramović, and a show of computer-generated video art by Ed Atkins. But on weekends Obrist becomes who he truly is: a traveler. By his count, he has made roughly two thousand trips in the past twenty years, and while in London I discovered that he had been away fifty of the previous fifty-two weekends. He goes to meet emerging artists and check in with old ones, to see shows small and large. The kind of culture he cares about is mobile and far-flung and can be grasped better on the move. He likes to quote J. G. Ballard's claim that the most beautiful building in London is the Hilton hotel at Heathrow Airport, and the postcolonial scholar Homi Bhabha's observation that "in-betweenness is a fundamental condition of our times." Obrist is enormously fond of quoting.

On the twelve weekends before I saw him in London, HUO, as Obrist is known, had been in Basel, for the art fair; Ronchamp, France, for a wedding in the chapel designed by Le Corbusier; Munich, for a talk with Matthew Barney; Berlin (where he maintains an apartment primarily to house ten thousand books) for an interview with Rosemarie Trockel; Frankfurt am Main, for a panel with Peter Fischli; Arles, where he is helping to design a new museum; Singapore, to meet emerging artists; Munich again, to interview the young Estonian artist Katja Novitskova; Los Angeles, for a panel on art and Instagram; Vienna, to guest curate an exhibit of unrealized design projects;

Majorca, to see Miquel Barceló's ceramic murals in the cathedral; Edinburgh, where Obrist's new memoir, *Ways of Curating,* was featured at the book fair; and Vancouver, where he appeared onstage with the novelist and futurist Douglas Coupland. In all these locales, he saw as much art as he could, but he also visited scientists and historians. He believes that, because culture is becoming more interconnected across geography and across disciplines, his knowledge must expand far beyond the visual arts: to technology, literature, anthropology, cultural criticism, philosophy. These disciplines, in turn, become tools in Obrist's attempt to fertilize the arts with fresh ideas.

Another thing that Obrist loves to do is talk. His favorite word is "urgent," to which he gives an elongated Mitteleuropean pronunciation. His words come out in an almost comical torrent, citations bobbing up and ideas colliding. Again quoting Ballard, he describes his curatorial work as "junction-making"—between objects, between people, and between people and objects. Words help Obrist process what he's seeing, and he often channels this energy into interviews with artists and cultural figures, which he calls "salons of the twenty-first century." He has conducted twenty-four hundred hours of interviews to date, talking to artists in their studios, on planes, or as they walk. Ideally, he records them using three digital recorders, to make sure that nothing gets lost.

In interviews, Obrist's volubility is paired with a deep deference. The architect Rem Koolhaas, in a preface to the Obrist compendium ...*dontstopdontstopdontstopdontstop* (2006), writes, "Usually those afflicted with logorrhea do not stimulate others to communicate; in his case, he rushes to let others do the talking." Obrist respects the art-world compact that though the work may be shocking, the conversation should be supportive. His questions are rarely personal, and when he is being interviewed himself he is similarly guarded: at one point, when I asked him to explain his manic personality, he said, "Maybe I'm in a permanent state of Pessoa's intranquillity." The interviews, over time, become books. He has published forty

volumes of them, records of interactions with everyone from Doris Lessing to the video artist Ryan Trecartin. In all, they represent Obrist's best claim to being an artist in his own right. He likes to say that he models himself on the impresario Sergei Diaghilev.

Obrist is not interested in all art equally. He can be skeptical about painting, because at this point, he told me, it's difficult to do meaningful work in that medium. For him, art, even old art, must be speaking to something current. "I don't wake up in the morning and think about Franz Kline," he said. The art he is most passionate about doesn't hang on walls and often doesn't have a permanent emanation. It can take the form of a dance or a game or a science experiment, and often leaves nothing behind but memories and an exhibition catalogue. (Obrist has published more than two hundred catalogues.) He looks for work that responds to the current moment or anticipates the moment after this one—Obrist is obsessed with the not-yet-done. His favorite question is, "Do you have any unfinished or unrealized projects?"

Much of the work that fits Obrist's ephemeral aesthetic could be called relational art, a term coined by the Parisian curator Nicolas Bourriaud in the 1990s to describe work whose content cannot be separated from its communal reception. (Obrist avoids using the term "relational" himself, in part because the artists never used it.) Abramović's *512 Hours* is a good example of relational art. There were few props, no script, and no installation; patrons were asked simply to join Abramović in an unadorned gallery space and conjoin their psychic energy. Another example of Obrist's taste is a work by Olafur Eliasson, the Danish-Icelandic artist whom Obrist helped discover. Obrist was one of a team of curators who invited Eliasson to contribute to a multi-authored opera/exhibition called "Il Tempo del Postino," first staged at the Manchester International Festival in 2007. Eliasson created a piece, *Echo House*, in which a reflective curtain dropped in front of the audience, showing audience members their every gesture. Each sound they made—

30

from coughs to claps—was mimicked sonically by the
orchestra. Soon the audience took the lead, improvising
a score of shouts and ringtones.

These works feel modern, in part, because they mirror
the group decision-making found online; at the same time,
they foster interactivity without leaving people isolated in
front of screens. The internet is always on Obrist's mind as
he scans for signs of cultural shifts. Although his shows
often playfully elevate the nonartistic to the curatorial—
Duchamp is a key figure—they also have a sadness to
them. He clearly believes that art offers a refuge at a time
when dark beasts, from capitalism to climate change, roam
the earth. His friend the artist Liam Gillick sees Obrist's
taste in art as made up in equal measure of "the melan-
cholic sublime and the idea of the productive machine."

Obrist, for his part, notes that his exhibits often
demonstrate what he has called a "quality of unfinished-
ness and incompleteness." He doesn't like art to have
temporal, spatial, or intellectual limits. The white cube of
the gallery irks him; closing dates bother him. He prefers
to think of exhibitions as seeds that can grow. For one of
Obrist's early shows, "do it," which debuted in Klagenfurt,
Austria, in 1994, twelve artists created "instructions"
rather than finished work. Alison Knowles, a New York
artist associated with the Fluxus movement, invited
visitors to bring something red and fill one of dozens of
squares in the gallery space with it. The exhibition never
looked the same from day to day. Other venues soon took
it on, and, over the years, artists have dropped in and the
instructions have changed. The exhibition, which just
celebrated its twentieth anniversary, is one of the most
widely produced art shows in the world. "do it" is the
signature effort of a curator who has followed his own
algorithm: see art, meet the artists, produce their shows,
use these shows to meet more artists, produce their shows
in turn. (In *Ways of Curating* Obrist calls social interac-
tions "the lifeblood of any curator's metabolism.")

Every year, the Serpentine holds a Marathon—a
festival that coalesces what Obrist has learned from his

travels and his reading and his interviewing. It is a combination of exhibitions, performances, and panels, with writers, visual artists, and cultural historians mixed in freely. The first Marathon, in 2006, was a twenty-four-hour rolling interview session that Obrist cohosted with Koolhaas. Afterward, Obrist was so exhausted that he had to check himself into the hospital. Koolhaas, who was then sixty-one, did not. "He was better trained, because he did a lot of sports," Obrist remembered. (Obrist now jogs every morning in Hyde Park.)

Last year's Marathon, which Obrist conceived with the French curator Simon Castets, was called "89plus," and focused on people born that year or later. Obrist explained, "1989 was the year the Berlin Wall came down, and it was the year Tim Berners-Lee invented the World Wide Web. This is the first generation to live its life entirely on the internet." Ryan Trecartin and some sixty others participated. Of course, two days were not enough to explore such a subject, and in Obrist's mind the exhibition never really ended. He and Castets are now planning an "89plus" event, dedicated to poetry, in Stockholm next year. In October, Obrist traveled to New York, and while he was there he held a planning meeting for "89plus" at a café in Greenwich Village. Surrounded by young poets and editors of alternative presses, he asked, "Do you know any poets who use Snapchat?" His voice was full of hope—what poetry could be more to Obrist's liking than poetry that vanishes?

Afterward, we toured art galleries. Obrist was in and out remarkably quickly, like a man with a plane to catch. If a gallery representative took more than twenty seconds to explain a work, Obrist turned his attention to his iPhone. Though he likes to learn, he doesn't like to be told what to pay attention to. But when he saw something he really liked he paused, and a light smile crossed his lips. This happened at the New Museum, which had on display the Lebanese artist Etel Adnan's quietly bold abstract landscape paintings, along with a typescript of her book-length poem *The Arab Apocalypse* (1989). He said,

"This has something of the Gesamtkunstwerk"—a complete, or all-encompassing, artwork. The term is often associated with the sprawling operas of Richard Wagner, but for Obrist it can be something much more nimble—a protean creation that is remade over time, absorbing fresh influences from people who engage with it. Something, in other words, much like himself.

Obrist was born in Zurich and grew up in a small town near Lake Constance. His father was a comptroller in the construction industry, his mother a grade-school teacher. An only child, he found school "too slow," and other Swiss found his vitality off-putting. "People would always say that I should go to Germany," he remembered. His parents were not particularly interested in art, but on several occasions they took him to a monastery library in the nearby city of St. Gallen. He admired the antiquity of the books, the silence, the felt shoes. "You could make an appointment and, with white cloths, touch the books," he said. "That's one of my deepest childhood memories."

When he was around twelve, he took the train to Zurich, where he fell in love with "the long thin figures" at a Giacometti exhibition. Soon he was collecting postcards of famous paintings—"my *musée imaginaire*," he calls it. "I would organize them according to criteria: by period, by style, by color." One day, when he was seventeen, he went to see a show by the artists Peter Fischli and David Weiss at a Basel museum. He was engrossed by their "equilibrium" sculptures—delicately balanced metal-and-rubber constructions. He had been reading Vasari's biographical sketches of the artists of the Renaissance, and it struck Obrist that he could try to meet creators, too. He reached out to Fischli and Weiss with this rap: "I'm a high-school pupil and I'm really, really obsessed by your work and I'd love to visit you." He told me, "I really didn't know what I wanted. It was just this desire to find out more." Fischli and Weiss were amused by the precocious Obrist, and welcomed him to their Zurich studio. They were filming their now famous short film *The Way Things Go* (1987), in which an old tire rolls down a ramp, knocking over a

ladder and setting off a chain reaction. On his visit, Obrist discovered a sheet of brown wrapping paper on the floor with the entire Rube Goldberg schema drawn on it. "It was almost like a mind map," he said.

Soon afterward, Obrist was entranced by a Gerhard Richter exhibition in Bern, and asked Richter if he could visit his studio, in Cologne. "*That* took courage," he said. He traveled on the night train from Zurich. "When I arrived, he was working on one of his amazing cycles of abstract paintings," Obrist said. They talked for ninety minutes. Richter was astonished by Obrist's passion: "'Possessed' is the word for Hans Ulrich," he told me. Richter recommended the music of John Cage. "We discussed chance in paintings and he said he liked playing *boules*," Obrist recalled. A few months later, Obrist was in a Cologne park, playing boules with Richter and his friends.

Obrist doggedly arranged to meet other artists whose work he admired. He went to see Alighiero Boetti in Rome. The feverish Boetti may be the only person ever to complain that Obrist didn't talk fast enough. (In his new book, Obrist writes with delight, "Here was someone with whom I had to struggle to keep up.") When Obrist asked him how he could be "useful to art," Boetti pointed out the obvious: he was born to be a curator.

Obrist wasn't sure what the job entailed, but he was intuitively drawn to the power of organizing art. As a teenager, he visited an exhibition at the Kunsthaus Zürich: "Der Hang zum Gesamtkunstwerk" (The tendency toward the total work of art, 1983). It highlighted four selections from the past hundred years of modernism: Duchamp's enigmatic glass construction *The Bride Stripped Bare by Her Bachelors, Even* (1915–23), and one painting each by Kandinsky, Mondrian, and Malevich. The works had been placed at the center of the Kunsthaus, heightening their effect. Obrist was struck by the intelligence of the man who had organized it: Harald Szeemann. Also a Swiss, Szeemann was one of several curators who had begun to bring a new inventiveness to the age-old job of selecting

art to illustrate a theme. Obrist saw the show forty-one times. (Later, of course, he interviewed Szeemann.)

Obrist did not yet feel qualified to put his stamp on the art world. He had the autodidact's anxiety about not knowing enough. For all his energy, he was not a revolutionary; he was an accumulator of information. But how to find out what artists were doing? "There wasn't then a place to study," he said. "I knew of no curator schools." So he designed his own education. He enrolled at the University of St. Gallen, and majored in economics and social sciences. When not in class, he set out to see as many shows as he could.

Switzerland is well situated if you want to make impulsive trips around Europe. Obrist spoke five languages: German, French, Italian, Spanish, and English. (His English was given a boost by *Roget's Thesaurus,* and he still keeps a vocabulary list in a blue notebook that he takes with him—among the latest words are "forage" and "hue.") He took the night train to avoid hotel bills and arrived in a city the next morning. "I would go to every museum and look and look again," he remembered. Then he visited local artists. He found that he could improve his welcome if he brought news of what he had seen, plus other artists' gossip and opinions. "I would go from one city to the next, inspired by the monks in the Middle Ages, who would carry knowledge from one monastery to the next monastery," he said. At Boetti's suggestion, he also inquired about unrealized projects, as every artist had some and felt passionate about them. Above all, he listened. "I was what the French call *être à l'écoute,*" he told me. His youthful intensity sometimes raised concern. Louise Bourgeois, after meeting the teenage Hans Ulrich, sleep-deprived and suffering from a cold, called his mother in Switzerland and urged her to take better care of her son.

In 1991, Obrist, in his early twenties, finally felt ready. By then, he estimates, he had visited tens of thousands of exhibitions and knew more artists than most professional curators. He chose to hold his first show in the kitchen of his student apartment. "The kitchen was

just another place I kept stacks of books and papers," he recalled. The minimalist gesture seemed appropriate, both as a reaction to the engorged art market of the eighties and as a reflection of the economic slump across Europe. It was also a playful homage: Harald Szeemann had done an exhibit in an apartment.

The idea of the show was to suggest that the most ordinary spaces of human life, cleverly curated, could be made special. Among the friends he included was the French painter and sculptor Christian Boltanski. Under the sink, Boltanski projected a film of a lit candle; the flickering could be seen through the gap in the cabinet doors. "It was like a little miracle where you expect it least," Obrist remembered. He publicized the exhibit through small cards and word of mouth; still, he was relieved that only thirty people came over the three months it was open. "I was still studying and couldn't have coped with much more," he said. Among those attending was a curator from the Cartier Foundation, a contemporary art museum in Paris. Soon afterward, Cartier offered Obrist a three-month fellowship. Obrist took it, leaving Switzerland for good.

Obrist quickly became a figure on the European art circuit. He was a clearing house for news and relation-ships, and he was generous—no sooner had he met some-one than he helped that person connect with others in his widening circle. If he stayed in a hotel, he cleaned out the postcards in the lobby and mailed them to everyone he could think of. "He had these big plastic bags," Marina Abramović, who met him in Hamburg in 1993, recalled. "I always wanted him to empty them and list all that was inside ... He would have information of every single human being—every artist living in a favela!" She remembered him as astonishingly innocent, an adjective that many still use for him. Many artists saw his unchecked commitment as a counterpart to their own. The French artist Philippe Parreno said, "For me, there is no difference between talking to him and talking to other artists. I am engaged at the same level." Obrist once conducted an interview with Parreno while driving him from Dublin Airport

to Connemara, and became so deeply absorbed that
he didn't realize he was on the wrong side of the street.

Obrist continued to set up shows in unusual loca-
tions. He put on an exhibit of Richter's paintings in the
country house where Nietzsche wrote part of *Thus Spoke
Zarathustra,* and a show in a hotel restaurant where
Robert Walser, the Swiss writer, used to stop during long
walks through the mountains. A third took place in 1993
in room 763 at the Hotel Carlton Palace, in Paris, where
Obrist was then staying. In one part of the exhibit, called
"The Armoire Show," nine artists created clothes for the
closet. With Fischli and Weiss, he toured the Zurich sewer
museum. "They had toilets and urinals on plinths and
had never heard of Duchamp," he marveled. This inspired
him to put together "Cloaca Maxima," which featured art
about lavatories and digestion. The show opened in 1994,
in and around the Zurich sewers.

During much of the nineties, Obrist held a part-time
position at the Musée d'art moderne de la ville de Paris.
He was the museum's "Head of Migratory Curation"—a
whimsical title that was, essentially, an invitation to travel
and find new talent. In 1995, Julia Peyton-Jones, then
director of the Serpentine, invited Obrist to put on a show
there. He proposed an exhibition called "Take Me (I'm
Yours)," in which visitors were asked to leave with an
object from the exhibit. It was a huge success, and many
felt that Obrist had subverted the passive expectations of
a museum visit: fill up on culture and leave. He had inject-
ed a note of interactivity into staid Britain. (*frieze* was less
impressed: "The viewers' participation is rewarded with
some worthless gesture or rubbish souvenir.")

While working on the Serpentine show, Obrist rented
a three-bedroom flat on Crampton Street in Elephant and
Castle, then a marginal neighborhood. He had fifty copies
of his house keys made and handed them out to artists
and curators passing through London. Conversations
with his guests often lasted through the night; then, at six
in the morning, Obrist went with whoever was still awake
to a nearby McDonald's—the only place around that was

open at that hour. Klaus Biesenbach, who is now the director of MoMA PS1, in New York, stayed with Obrist for a while. One day, Biesenbach told me, a Korean artist named Koo Jeong A arrived. Koo, then in her mid-twenties, made delicate installations: heaps of domestic dust, an arrangement of leaves, piles of coins. Her work was ephemeral, and she hated to be interviewed. Obrist had shown some of her efforts in Paris and had invited her to set up an installation in the Crampton Street flat. In the morning, the three would meet for discussions, Biesenbach recalled. "And one morning, I remember, they came out of one room. Wow, I thought, they must have had a meeting before. Why didn't they invite me to the meeting? And the next morning they came again out of the room." Obrist and Koo have been together ever since.

The sharp-tongued English press continued to poke at Obrist. Adrian Searle, an art critic for the *Guardian*, wrote in 1999 that he often found Obrist's curating "deeply irritating." But Obrist's coterie is less reviewers than artists, collectors, and other curators, who are almost always interested in his projects. Perhaps his greatest triumph was "Cities on the Move," a collaboration with the Chinese curator Hou Hanru, which debuted in Vienna in 1997. It was a timely exploration of the artistic and demographic landscape of Asia—a look at what Koolhaas, a participant, called "cities of exacerbated difference." Scaffolding permeated the installation; there were rickshaw taxis festooned with fabulous colors. Conventional artwork peeked out from corners. In the London incarnation of the show, Koo set up a bedroom in the gallery while finishing an installation; visitors got to see the blankets and clothes that she had left behind. This time, Searle praised Obrist: "His strengths as a kind of cross-disciplinary impresario have found their subject. He knows not only how to create chaos, but also how to curate it."

In 2000, Obrist began to tire. He and Koo wanted a more stable base for their lives and he wanted to curate solo shows. "There is nothing deeper than to work for a year with the same artist," he said. So he accepted an offer

from the Musée d'art moderne de la ville de Paris to be
a full-time curator. He remained in France until 2006,
when Julia Peyton-Jones made him her codirector at the
Serpentine. Koo and Obrist now share a small apartment in
Kensington, near the gallery. When I visited Obrist there,
the closest thing to food in the kitchen was Diet Coke.
The walls were almost bare. Fluorescent lights drenched a
living room filled with books arranged on industrial shelv-
ing. Among the titles were Ben Lerner's metafictional novel
10:04 and *On Touching—Jean-Luc Nancy*, Jacques Derrida's
monograph on "the sense of touch." I was bemused that a
person who lived by his eyes lived in such a nondescript
place, but Obrist's interest in anything outside high culture
is fitful. I never heard him talk about sports or favorite
restaurants or how much something costs. He has never
made a cup of coffee, and tried cooking only once; the
phone rang and he forgot the saucepan, which caught fire.

Sleep has always seemed extraneous to Obrist.
During the early nineties, he tried Balzac's caffeine re-
gime, drinking dozens of cups of coffee a day. Then he
switched to the Leonardo da Vinci method, limiting
himself to a fifteen-minute nap every three hours. Now
he tries to get four or five hours every night. He has an
assistant who comes to his apartment at midnight to help
him with his interviews and books. "That way, when I'm
out, I know it's time to go home," he said. Obrist sleeps
while the assistant works, then wakes up and takes over.
He still likes to meet people at dawn for conversation: in
2006, he founded the Brutally Early Club, which meets
at 6:30 a.m. at various sites around London. (Another of
Obrist's conceits is that modern life is characterized by a
decline in ritual. He ascribes the idea to Margaret Mead.)

Obrist first appeared on *ArtReview*'s most-powerful
list in 2002, and by 2009 he had risen to the top. His
rolling-suitcase approach to life seemed to reflect changes
in the art world, which was becoming faster, bigger, and
vastly more international. London alone has about eight
times as many galleries as it had in 1980, and now Beijing
and Baku and Mexico City compete for attention with

Paris and New York. Increasingly, the most powerful curators are those who have the stamina (and the budget) to see enormous amounts of art and distill it into themes and movements. Among the frequent fliers are Biesenbach, of MoMA PS1; Daniel Birnbaum, of the Moderna Museet, in Stockholm; and Massimiliano Gioni, of the New Museum, in New York. Obrist and Biesenbach first met, by chance, on a night train to Venice in 1993, on the way to the biennial. Biesenbach, who was putting on shows in Berlin, was trying to sleep, and Obrist plunged into his compartment and kept him up the whole night. "We discussed how it's urgent to capture the Berlin moment," Obrist recalled. Five years later, they helped put together the first Berlin Biennale, and they have been close collaborators ever since. Birnbaum, who started out as a critic and then became a dean at an art academy, was spurred to become the sort of roving international curator Obrist is after years of conversation with him. "Hans is enthusiastic, and somehow he can make other people enthusiastic," Birnbaum said. Obrist was also one of Gioni's original guideposts. As a university student in Bologna, Gioni began a correspondence with Obrist that informed his practice when he entered the art world. "He really established curating as a term, a discipline, a modus operandi," Gioni said, adding, "The Dadaists had Tzara; the Surrealists, Breton; the Futurists, Marinetti; and now the international global art world has Hans Ulrich Obrist."

In many ways, an Obrist generation is running the nonprofit art world. In 2010, Jens Hoffmann, the top curator at the Jewish Museum, who considers Obrist his mentor, wrote in *Mousse Magazine*: "Almost all of the innovative work done by exhibition makers in mainstream art institutions over the last decade owes much to ideas that Obrist first introduced." Not everyone considers this a good thing. Claire Bishop, an art historian at the City University of New York told me, "The world of contemporary art is fast-moving and superficial and demands constant feeding, and he's a prime example."

Though Obrist is often assumed to be the kind of megalomaniac who is more prominent than the artists he shows—and who is willing to crush the heterogeneity of artists' work in order to extract coherent themes—that assumption doesn't properly capture him. He seems as egoless as he is guileless and stateless. Liam Gillick said, "When you work with him, he absolutely protects you and creates enormous space for what you need to do—and yet no one knows he's done it." Indeed, it's hard to reconcile the idea that Obrist is a domineering superstar with the fact that nearly all his shows are collaborations with other curators. As Gillick puts it, "He stands against a certain sort of very assertive, very authored curating that was prominent when we were young. He has a real anti-authoritarian streak."

I first met Obrist in Los Angeles, in July 2014. He was there to conduct one of his periodic checks on the city's art galleries. He also planned to visit the studios of John Baldessari, Ed Ruscha, and Chris Burden, and attend the Los Angeles biennial, Made in L.A., at the Hammer Museum. Finally, there was the panel on Instagram to host. Obrist is an avid user of the medium, and has more than one hundred thousand followers.

The story of how he discovered Instagram is typical. During a breakfast in 2012 with Ryan Trecartin, the video artist downloaded the app onto Obrist's phone (without asking). Next, Trecartin posted to his Instagram followers that HUO had signed up. Obrist was curious, but he wondered what to do with the new tool. Inspiration was sparked by other well-known friends. On a visit to Normandy, he went for a walk with Etel Adnan, the Lebanese artist. During a rainstorm, they stopped at a café, and she wrote him a poem by hand. This made Obrist remember Umberto Eco's comments on how handwriting was vanishing; he also thought of marvelous faxes he had received, all handwritten, from J. G. Ballard, when he interviewed him, in 2003. Adnan's handwritten poem became one of Obrist's first Instagram posts. Soon afterward, he remembered that another friend, the artist

Joseph Grigely, who is deaf, uses Post-it notes to communicate; they are often incorporated into his art. HUO began asking dozens of artists to write something on a Post-it. He posted the scrawlings on Instagram. Yoko Ono wrote, in soft black ink, "Time to Tell your love." Richter filled a dun-colored Post-it in his jagged hand: "Art as part of our insane capacity for hope makes it possible that we cope with our permanent madness and our boundless brutality." Obrist just surpassed eight hundred posts. "Maybe the iPhone is the new Nanomuseum," he told me, hopefully.

Obrist's first stop in LA was at Baldessari's studio, in Venice. He arrived there at one o'clock, in a black SUV with a driver. He was wearing a three-button suit, a white shirt, and blue tennis sneakers. An old photograph of Obrist, which can be found on the internet, shows a vigorous young man with tousled hair and intense eyes, but the da Vinci regimen and air travel have been punishing. He is now nearly bald, and the remaining tufts of hair are white. He had chosen not to sleep the previous night in London, so that he could sleep on the flight. That, in tandem with a hood that he puts on for quick naps at his office, is his current sleep-minimizing technique. He had with him two enormously heavy pieces of luggage. "It is my exercise," he explained. The suitcases were filled mostly with his publications, which he planned to hand out.

We entered the studio through a gate. "Every visit to Los Angeles begins with John, and has for twenty years," Obrist told me. Baldessari, eighty-three, tall and shambly, greeted us. Baldessari has contributed work to various Obrist exhibitions, and would happily do so again. "He's like a good mom," he told me. "Everything my son has done is good." He took us to a room where new work lined the walls. The Städel Museum, in Frankfurt, had commissioned him to reinterpret paintings from its collection; he had responded by creating large panels that juxtaposed fragments of text from screenplays with visual details scanned from works at the Städel. In one panel, movie dialogue in which two lovers discuss money was paired with a gorgeous closeup of a leg from Cranach the Elder's

1532 painting *Venus*. Did the words and image create a plot? Or had Baldessari merely made a surreal juxtaposition? The ambiguity delighted Obrist, who pointed out that Baldessari had restored context that Cranach had deliberately stripped out. "When you have a Venus, you usually have a Cupid," he explained. He told Baldessari, "This is amazing. So exciting!" He drew out the syllables: *eg-zi-tink!* Obrist has a gummy, soft smile, and a Brunelleschi dome of a forehead. He carries his shoulders back when he stands, and the effect is to shorten his arms, making him look like a boy.

Afterward, we sat in Baldessari's study, amid tables on casters stacked neatly with art magazines. "Well, that's what I've been up to," Baldessari said.

"Congratulations," Obrist said. "None of this work was here six months ago!"

Soon, Obrist was back in the SUV and Baldessari's work had prompted an idea: it was wise not to "isolate contemporary art" but to "create a continuum with history." Baldessari's project not only enlisted the spectator in making meaning; it created a junction between the living and the dead. Just as old art must look forward, new art should look back.

Obrist's next visit was to Ruscha, whose studio is a low unmarked building in Culver City, five miles away. Baldessari and Obrist have a rapport: they are both impersonally personable. Ruscha has a cooler nature, and though he recognizes Obrist's centrality in the art world—"I see his name pretty much constantly"—he is also skeptical of him. "His telephone is continually tinging and leaving twicks and tweets and all that," he told me, adding, "I'm like one little fragment of his interest."

Ruscha took Obrist out back to an open-air studio to show him new works in his "Psycho Spaghetti Western" series, which was inspired by roadside debris. Ruscha did not seem like Obrist's kind of artist: his paintings have a deeply American irony that seemed destined to elude the earnest Swiss. But Obrist sought, as always, to make a connection. The strewn objects on Ruscha's canvases,

he declared, reminded him of *In the Country of Last Things*, a dystopian novel by Paul Auster.

The tour finished. Ruscha took a seat behind a cherrywood desk and fixed Obrist with his blue eyes, a dog at his feet. Obrist asked where the new paintings would be exhibited, but it was not as easy to gain traction with Ruscha as it had been with Baldessari.

"In Rome. At the Gagosian Gallery."

Obrist, name-dropping, said that he'd once visited Cy Twombly at his studio in Rome. Ruscha didn't seem to care. Obrist then expressed admiration for *Guacamole Airlines*, a book of drawings that Ruscha had made in 1980.

"That was forty years ago," Ruscha said.

This must have been what it was like when Obrist was a youth, surrounded by taciturn Swiss. Obrist's arms tend to go into motion when there is silence. He asked Ruscha about a show the artist had organized at Vienna's Kunsthistorisches Museum, in 2012. "What did you do, exactly?" Obrist asked.

Ruscha said that he had taken some "meteorites and stuffed animals and some Old Masters" and put them on display. He had included one of his own paintings.

"One no longer isolates so much of contemporary art," Obrist said, sharing his latest epiphany. "The contemporary is now connected to the historical."

Ruscha continued to smile. Eventually, he said, "They told me not to go throwing that word 'curator' around. I was told I was just assembling an exhibit."

"Maybe we need a new word," Obrist said.

"Yah."

"I don't want to take more of your time," Obrist said, after a moment.

On his way out, Obrist asked Ruscha to contribute to his Instagram project. Ruscha told me later, "I gave him something that said, 'On the bag before the tag.' Some baseball announcer said that." He added that he had no idea what Instagram was. Obrist, in turn, didn't catch the baseball reference.

The next day, Obrist went to visit Chris Burden, who lives in Topanga Canyon, north of the city. He was excited: Burden was an important performance artist in the seventies, and Obrist admires the installations that he has been making in recent years. Outside the Los Angeles County Museum of Art, Burden created a dense plot of refurbished lampposts—a glowing garden that has become an actual junction for nighttime visitors. Burden also creates elaborate toys and contraptions that speak to the geeky side of Obrist, as Fischli and Weiss did long ago.

After climbing a rugged road, we arrived at the top of a small mountain. Burden met us at the door. Squat and muscular, he looked as if he had been lifting weights and was still mad at them. "I can give you a tour," he said. "Or maybe you have something to tell me." He didn't want photographs taken of his hangarlike studio. "Next thing you know, they're on your website," he said. Obrist put his recorder away. But he is adept at winning over artists. After touring the studio, they went outside, past rows of lampposts, ordnance shells, and mermaid caryatids. Soon they were clambering around on a forty-foot steel tower Burden had built, like two boys with a giant erector set.

Back inside, Obrist asked him about unrealized projects.

"I had a dream of building this city called Xanadu," Burden said. He showed Obrist some drawings.

"That is a huge unrealized project!" Obrist said. He clapped his hands with pleasure.

"A real city that no one lives in."

"That's awfully exciting. I had no idea about this!" He promised to visit Burden again on his next trip. As the SUV careered down the hill, Obrist checked his emails and texts and pronounced the visit "super-super-productive."

In mid-October, Obrist put on the Serpentine's ninth annual Marathon, in Hyde Park: "Extinction Marathon: Visions of the Future." The press had framed the show as a depressing alternative to the ebullient Frieze Art Fair taking place in Regent's Park. Nevertheless, the Serpentine event drew a crowd, with more than four

thousand attendees. It had a carnival feel, underscored by three big Mylar balloons, spelling out "HUO," that were tethered to a tent where the speakers gathered. When I arrived, Obrist, wearing a blue single-breasted suit, was making rapid-fire introductions among the gathered artists, ecologists, writers, researchers, activists, sages, and prognosticators. He seemed to be going slightly mad.

Obrist told me that his own unrealized project is to found a new version of Black Mountain College, the defunct North Carolina retreat where, sixty years ago, top practitioners in the arts, culture, and the sciences taught and exchanged ideas. That ambition, combined with his admiration for Diaghilev, had shaped the Serpentine event. The guiding presence was the eighty-eight-year-old artist Gustav Metzger, who had sat through the entire first Marathon. Although he is ailing and in a wheelchair, he attended nearly all of this year's proceedings. Obrist, in his opening remarks, declared that Metzger—a longtime environmental activist—had helped inspire the theme of "Extinction." Julia Peyton-Jones, who sometimes plays the goof to Obrist's *Luftmensch*, dedicated the Marathon to the pangolin—an adorable, endangered mammal that looks like an anteater.

The performances and the talks took place on a small stage with a backdrop of an oversized hand pointing at black trash bags. To begin, several scientists delivered bad news. At least eight hundred and seventy species had been wiped out in the past four hundred years. Jonathan Baillie, of the London Zoological Society, noted that, of the seven remaining northern white rhinos, one had died the previous day, in Kenya. Jennifer Jacquet, an environmental social scientist at New York University, spoke about the decimation of the Steller's sea cow, which was hunted for sport—and for its blubber—in the eighteenth century.

Suddenly, Gilbert & George, the painting duo known for cheeky irony, came onstage, in bespoke nibbed suits and bright-colored ties. They unfurled spray-painted posters. BURN THAT BOOK, Gilbert's said. FUCK THE PLANET, George's said. They were lampooning the ignorance of climate change deniers, but the audience wasn't sure what

to make of them. After a few more speakers, Obrist stood up. "Coffee breaks are urgent!" he said.

Later in the day, Stewart Brand, who created the *Whole Earth Catalog*, amused the crowd when he took a showy tumble off the stage, to impersonate the death of a lemming. Brand then spoke about efforts to clone extinct species. Passenger pigeons would come first, he promised, then mammoths. The more excited Brand got, the more uncomfortable the audience seemed.

Obrist informed me that his friend John Brockman, a science impresario and literary agent, had selected most of the scientists. "We don't know the important scientists, and they don't know the good artists," Obrist explained. Perhaps as a result, the science had an austere implacability to it, and the art often seemed to aestheticize tragedy. Benedict Drew, a young English artist, created a hectic digital montage that included a disembodied head and images of a garbage dump intercut with ominous messages: WE ARE DONE FOR. The piece, weighed down with sinister synthesizer music, was called *NOT HAPPY*. When the words "Why you so happy Pharrell" flashed, the audience laughed in relief.

At times, the worlds of science and art came together: an oddly moving presentation by Trevor Paglen focused on communication satellites that will circle the earth for billions of years after humans are extinct. But most of the time the scientists conveyed the information and the artists the hurt. A bewildering variety of extinctions were invoked: of plants, of gays, of languages, of books on paper, of celluloid film. Obrist, surrounded by half-drunk cups of coffee, got up to introduce presenters and then sat back down in the front row, where he and Peyton-Jones, who sat by his side, passed notes to each other and to their assistants, who sat behind them.

The Marathon ended with a new participatory piece by Yoko Ono that was read aloud by Lily Cole, a model and environmental activist, for which the audience was given small bells to ring.

"Don't try to change the world, that's a concept floating on our horizon," Cole read. "Just use your wits

and change your heads." On a large screen by the stage, the words "Surrender to Peace" appeared. In the audience, bells chimed prettily.

The message seemed at odds with much of the Marathon. Wasn't changing the world the point? Then again, there was not a single policy official among the eighty participants. The real goal, it seemed, was to conjure a sense of community. "It was quite magical," Obrist said of the chorus of bells. "The participants did at least 50 percent of the work." He added that "smaller actions can lead to bigger actions."

Obrist had brought together an eye-catching roster of participants, but epic conversation was not well suited to addressing the urgent topic of extinction. It sometimes seems that Obrist doesn't care so much what people say, as long as they keep talking. In 2003, Hal Foster, an art historian at Princeton, published an essay that touched on Obrist's first collection of interviews. "Formlessness in society might be a condition to contest rather than to celebrate in art," Foster pointed out. Nothing at the Marathon was as strong as a Metzger work titled *Flailing Trees*: twenty-one willows planted upside down in concrete. The installation was first displayed in 2009, at the Manchester International Festival. Metzger had been included in that festival at Obrist's suggestion, and it had been a smart one: *Flailing Trees* is rigorous, beautiful, sad.

After the Marathon, Obrist told me that the performance artist Tino Seghal had watched a live stream of the Marathon and had especially enjoyed a talk by Elizabeth Povinelli, an anthropologist at Columbia University. "Tino's reading her book now!" Obrist said. Who knew what collaborations might result? This was a different sort of Gesamtkunstwerk, he said, "one more in time than in space." As the crowd dispersed, HUO posed in front of the balloons with his initials. "This topic isn't going to be solved in a night," he said. "I see the 'Extinction Marathon' as a movement." Then he noted, "I have a 5:40 a.m. train. The Eurostar to Paris."

For
Hans Ulrich
Obrist

I've known Hans Ulrich since he was very young. We met when he was a bit over twenty years old, actually, in Paris.

He was introduced to me by *Parkett* editor and curator Bice Curiger, a mutual friend. From that first moment, Hans Ulrich was so vibrant, so full of energy, at the verge of making me a bit nervous, honestly. He already had this amazing fervor to learn more and more things, to meet people, all kinds of people: writers, sociologists, scientists, and, of course, artists and also architects, as it appeared. A kind of fervor to swallow up the whole world.

We spoke about the work of Gerhard Richter, an artist that I had also always admired for his paradoxical talent to combine both traditional painting and experimental openness. I found it remarkable that the then very young Hans Ulrich was attracted by such an artist, with whom he had already been in close contact for a while, and with and for whom he was going to do many books and exhibitions—like the remarkable small presentation of Richter's work at the Nietzsche Haus in Sils Maria, Switzerland. The dialogue with Richter is certainly an essential and recurrent theme in Obrist's biography to this day. But Hans Ulrich always follows many paths at the same time, at breathtaking speed and intensity. He doesn't stop expanding his creative network of people—which you tend to become part of once you get in touch with him.

Our Paris meeting was the beginning of an almost uninterrupted period of doing things together: some volatile projects, but also more permanent and serious ones, conversations, and other collaborations. It became more intense and interesting over time.

It started with a first interview whose first transcript was a total mess when it came back on my table. That was when I understood that working with Hans Ulrich was maybe interesting but also painful, as if the invested energy would be missing at the end when things had to fit together and be finished properly. That was in the early years of Hans Ulrich, when he was far less organized and without the infrastructure he now has at his London office

at the Serpentine. In the meantime we have talked so often together that the transcribed conversations became more orderly and structured, yet they nevertheless maintain the freshness of the early moments of our friendship. Hans Ulrich's position is different from most art historians: less academic, often unexpected and driven by an incredible curiosity and enthusiasm for uncovering hidden connections between people and their disciplines.

He brought in something new that didn't exist in the world of art before; since early on he curated his creative network as if it were a kind of social media avant la lettre. He brings together artists, architects, philosophers, writers, scientists ... with a focus on forms of creativity beyond traditional categories and values. Forgotten people and their work are being brought back, to shine again and inspire the younger generations of today, such as sociologist Lucius Burckhardt, who was one of our professors at the ETH Zurich in 1971–72. Obrist invited us to design a pavilion dedicated to Burckhardt for the 2014 Venice Biennale of Architecture, which triggered a real renaissance of his concept of "strollology."

Another remarkable quality is that Obrist sees creativity as an opportunity to bring people together rather than set them apart. Even if he may have priorities, he would never give anyone the impression of being excluded or to favor one artistic position over another. In the jealous and competitive field of art and architecture it is rare to avoid gossip. Obrist, however, never speaks about other people. Not one bad word, no cynicism, not even irony. He connects one to another; if someone is not there, he tries to call them on the phone and make them part of the ongoing conversation.

So, any prize or any title given to him, I think he very much deserves it. And I really look forward to doing more things with him in the next years ...

Thank you for all of this, Hans Ulrich.

huo
long lists
mountains
hotel carlton
robert walser
peter & david
snowing may
hotel walser
mountains
postcards
migrateurs
kaspar
dakar
cities
books
marathon
cedric price
mountains
portraits
london
memory
transform
heiner
huo

The Obrist
Factor

Joseph Grigely

Every few weeks—sometimes it's more often, sometimes less—Hans Ulrich Obrist sends to me a package enclosing his most recent publications. He began sending these packages in the mid-1990s; initially the route was from Paris to Jersey City, but as we both moved, the route did too, and the packages are now sent from London to Chicago. My ongoing task is to catalogue and archive Obrist's editorial and curatorial production, as well as his published interviews and related writings. I am curating the curator, so to speak. Obrist is intensely prolific, and his bibliography now has thousands of entries: books he has written, books he has edited, exhibition catalogues, essays in magazines, interviews, transcripts of conversations, exhibitions produced and disseminated as publications, exhibition posters, announcement cards, printed buttons, event programs, and supplementary material—primarily scans of photographs and documents from Obrist's notebooks, exhibition proposals, correspondence, and a collection of "conversation" notes that Obrist wrote when talking with me over the past twenty years. The archive is comprehensive, but it is not definitive, for Obrist and his production are always in motion; the archive is a mass of material growing exponentially. Over time, the archive's bibliography has evolved not so much as a document mapping archival objects, but more significantly as a trace of Obrist's activities interfacing people, institutions, and places, and creating from these situations an oeuvre that eschews conventional metrics of description and measurement.

Obrist and I started working together in 1995, when he was organizing an exhibition series called "Migrateurs," at the Musée d'art moderne de la ville de Paris. The "Migrateurs" exhibitions migrated throughout the museum, and even outside of it: they took place in the reception area, the hallways, the bookshop, the café, the administrative offices—generally incidental locations. As Obrist said in an interview, "With this kind of set-up, all of a sudden, art—in a Robert Musil way—can take

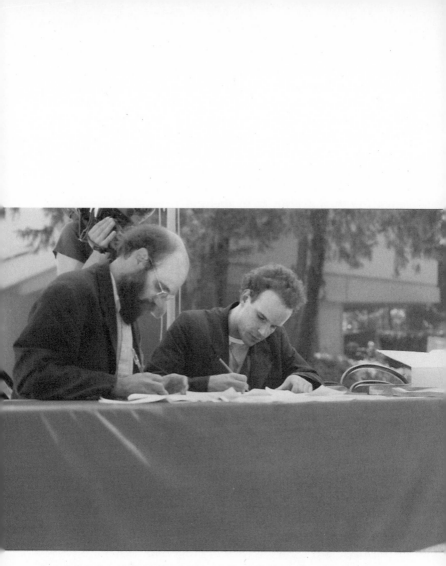

Joseph Grigely and Hans Ulrich Obrist at the 47th Venice Biennale, June 1997

place where you expect it least."[1] These exhibitions also included a series of modest, pocket-sized publications priced at around ten francs—they were less catalogues of the exhibitions than footnotes to the exhibitions. It was at this time Obrist began rethinking and reshaping many contemporary exhibition practices. He curated exhibitions that were publications, like *Point d'ironie* (1997–ongoing). He organized exhibitions that involved scientists, psychologists, musicians, and other people whose work ostensibly had nothing to do with visual art. He presented exhibitions in some of the most inconceivable locations: vacant offices, monasteries, even inside airplanes. In his 1993 exhibition "Hotel Carlton Palace, Chambre 763," Obrist transformed a hotel room into a large-scale exhibition for sixty-eight artists (including a smaller group show, "The Armoire Show," which took place within the room's tiny armoire). His Nanomuseum consisted of a small, folding silver frame that could be carried in a coat pocket like a cigarette case. It was precisely 37.4 mm wide and 55 mm long and held two images at most: one on the left panel, and one on the right. It was a traveling exhibition that traveled like few exhibitions did. Obrist's exhibitions in the 1990s worked in a way to complicate, or (to use Obrist's own word) "complexify" exhibition practices. To paraphrase the late American artist Chris D'Arcangelo, who died in 1974: "He did things in his own little way."

It is important to note that Obrist's early approach to curating was both studied and deliberate: he read Alexander Dorner and Robert Walser closely, and sought to understand the catholic experience of curators across the artscape: he interviewed Harald Szeemann, Walter Hopps, Johannes Cladders, as well as Pontus Hultén and Seth Siegelaub. He also talked with artists—Alighiero Boetti, Louise Bourgeois, Christian Boltanski, Fischli and Weiss, and Gerhard Richter, among dozens others— about how they'd like to present their work apart from

1. Hans Ulrich Obrist, "Moving Interventions: Curating at Large," interview by Vivian Rehberg, *Journal of Visual Culture* 2, no. 2 (2003): 153.

the usual conventions of exhibitions. It was an approach to curating that assimilated history, while at the same time both respected it and expanded it. Once, when we were working on the exhibition "Laboratorium" in Antwerp in 1999, I took an automobile drive with Obrist—the only time I took a drive with him—and predictably enough, our trip across the city involved going the wrong way down one-way streets. Not with reckless abandon, but with considered care. He drives like he curates, and he curates like he drives.

It didn't start this way though—it all started with a certain anxiety that reminds one of the nineteenth-century poet John Keats, facing what the critic Harold Bloom calls the "anxiety of influence." Early in his career, Keats was trying to find a particular kind of poetic invention—something that would mark him apart from both his contemporaries like Byron and Wordsworth, and those who came before him. Shakespeare, Milton, and Spenser had already accomplished so much and innovated in so many ways—what was there left to do? For Keats the solution was to concentrate on the poetic image, not the poetic narrative. He did this by creating images and phrases that were acknowledged—either loved or vilified—for the way they broke away from the expectations of convention. What is uniquely Keatsian is his ability to give us what William Butler Yeats called "the right word that is the surprising word."[2] Obrist likewise felt the anxiety of history, and what had been accomplished in terms of contemporary exhibitions: as a teenager when crisscrossing Europe to see exhibitions and artists, he mused to himself that "everything had really already been done."[3] A few years later, Obrist's first show was virtually a counterpoint to everything he had seen in his years surveying contemporary exhibitions:

2. The first person to comment on this was the inimitable British critic John Bayley, in *The Uses of Division: Unity and Disharmony in Literature* (New York: Viking, 1976), 116.

3. Hans Ulrich Obrist, "The Elephant Trunk in Dubai," interview by Ingo Niermann, in *Everything You Always Wanted to Know about Curating*, ed. April Lamm (Berlin: Sternberg Press, 2011), 33.

in 1991 he organized in the unexceptional space of his apartment kitchen in St. Gallen, Switzerland, an exhibition titled "The Kitchen Show." A year later, he produced a catalogue of the exhibition entitled *World Soup*—separate pages contained in a folder-like binding—which, rather than simply cataloguing the exhibition, remade it as a portable exhibition structure. If "The Kitchen Show" was radical as an exhibition, *World Soup* was equally radical as a catalogue.

This is what I call the Obrist Factor.

The Obrist Factor is important—both to artists and curators—for various reasons. The evolution of Obrist's curatorial practice—from a DIY show in his kitchen apartment, to his current position as artistic director of the Serpentine Galleries in London—offers an evolving outline of contemporary curatorial history. In February 2008, the director of White Columns in New York, Matthew Higgs, initiated a new series of exhibitions on curators. As part of his rationale for the series, Higgs wrote in the introduction to the catalogue:

> We know very little about individual curators' histories, which is surprising given the proliferation of curatorial activity in the past twenty years or so, and the parallel debates around exhibition-making. Curators' resumes tend to circulate only behind the scenes. Consequently there are many "secret histories"—of exhibition-making, curators' writings, collaborations with artists, etc., that remain largely unknown.[4]

There are many compelling reasons to study these histories, and for me there is one reason in particular that I want to address: the extent to which exhibitions are a means by which art is disseminated, and how—if we look at this historically—we realize that the means and modes of dissemination are constantly changing. As an

4. Matthew Higgs, introduction to Bob Nickas, *Exhibition Scrapbook 1984–2008* (New York: White Columns, 2008), n.p.

artist, making art is only part of the task; the other part is bringing the work to the public. It involves a constant effort to create, if not also remake, conditions by which the work can be shared, and venues at which this might take place. With each new generation of artists comes a new generation of curators, of collectors, of exhibition venues, and the means by which the dissemination of art is newly made. It's important to initiate possibilities and continuously reinvent them, while simultaneously study-ing and historicizing our evolving contemporaneity.

Where Obrist played such an important role is in turning exhibition from a noun into a verb, by activating many curatorial conventions that were in danger of becoming moribund. He did not do this alone; his prede-cessors provided for him a conceptual framework, and the artists he worked with provided the inertia to real-ize exhibitions that migrated within the museum (like "Migrateurs") or took place outside traditional exhibition spaces, either as interventions to publications (his museum in progress exhibitions in the Austrian daily newspaper *Der Standard,* for example), or intervention exhibitions in houses devoted to historical figures (Sir John Soane's house in London; Luis Barragán's house in Mexico City) or in entirely new venues (Hotel Carlton Palace in Paris; the portable, pocket-sized Nanomuseum; "Laboratorium" in the offices and laboratories of Antwerp). Instead of the curator working *for* the artist, Obrist repositioned himself as someone working *with* the artist in a dialectical exchange. He is fond of saying that everything he does begins with a conversation, but even more important than that is the sense in which an underlying exchange deter-mines the trajectory of any project: he knows where it begins, but is unsure where it will end, or if it will ever end.

Obrist's archive is not just about his exhibition history, but the way that history is represented by his publications. The publication interventions he curated are especially important in this regard. In 1993 he organized a project with Alighiero Boetti for Austrian Airlines, where Boetti's stylized paintings of planes

crossing a rich blue sky were published as an intervention in the airline's in-flight magazine, and the paintings were also made into a series of jigsaw puzzles that were distributed to children on flights. Interventions like this have become one of Obrist's stylized trademarks: they work differently than conventional exhibitions because in these cases people do not go to the shows; the shows go to them. It is the exhibition modality that moves into the "non-places" of everyday life, thereby transforming those spaces. Museums have always sought to engage new audiences; Obrist has made it a normative practice to take art and art exhibitions into the space of public life, and work with artists to create new art for these spaces. There are no neat taxonomies in Obrist's world—it's a world of entanglements, with disciplines, genres, people, and exhibitions departing from their expected roles. The Obrist Factor assumes nothing is stable, that everything and anything is possible, and that—as Obrist once famously remarked—"routine is the exhibition's greatest enemy."[5]

The Obrist Factor accepts that both art and art exhibitions are malleable, in the sense they can be adapted and changed at any time. When Obrist organized "Hotel Carlton Palace" in 1993, work was constantly added to the exhibition as it progressed over the course of a month. The Obrist Factor likewise dares artists, institutions, and funders to think *otherwise*. Obrist's first book of essays, arguably a collection of dares, was titled *Delta X: Der Kurator als Katalysator* (1996). But the challenges being posed are not about difference

5. Obrist, "Elephant Trunk in Dubai," 50. "In May of 1992, I founded the Robert Walser Museum as a museum on the move with its starting point at the Hotel Krone in Gais (Appenzell, Switzerland). The migratory museum consisted first of all of a small, movable vitrine. The idea was to establish a non-monumental, modest, and very discreet museum, an elastic institution which could permanently question its own definitions and parameters and which was less dependent on static hardware than big structures, to maintain the museum in a permanent transformation and try to avoid routine." Obrist, "Moving Interventions," 148.

for its own sake: Obrist's notion of difference is conditioned by history, and is considered rather than arbitrary, respectful rather than flippant. It's also important to experience, even live with, the vicissitudes by which art moves through the lives of human beings. Most exhibitions are ephemeral constructions—for many of them, their enduring beauty is in part their absence, and absence leads to longing. Exhibitions like Szeemann's "When Attitudes Become Form" (1969) or Obrist's "Kitchen Show" perpetuate an absence that makes them iconic as a presence. That is why one cannot see too many exhibitions or see too much art: because these moments of contact sustain an ongoing, if unwritten, history of relations between and among exhibitions, which is especially important given that there is little documented history of individual exhibitions, and how they are curated, organized, and realized.

Representing the Archive

Obrist's archive of publications and publication projects begins with his first exhibition, "The Kitchen Show" and continues to the present. The process of mapping the archive in relation to Obrist's curatorial history involves creating relationships—folding one practice or idea or event into another, similar to Obrist's affinity for inviting one artist or curator into the life of another: one of Obrist's favorite activities is to send emails to two artists whose travel has brought them into proximity to each other, and to tell them, "It is urgent that you meet!" Likewise, in the archive, it is "urgent"—a word Obrist uses to convey a condition of immediate importance— for the various documents, events, and people to all come into contact with each other.

In the summer of 2014, the archive of publications and publication projects was moved from my studio to MacLean 705 at the School of the Art Institute of Chicago. MacLean 705 is an atrium outside my office, and for several years I have used it as a project room devoted

to short-term exhibitions that explore the space of art and human relations.[6] Even while the exhibitions take place, the room continues to be used for tutorials, meetings, and related institutional events, the projects alternately foregrounding and backgrounding the activities of the room. The budget is minimal, and administrative support is likewise incidental: the space is open when the door of MacLean 705 is open, and by appointment.

To move the archive we installed over forty-five meters of shelving to hold approximately 235 archival boxes containing physical documents. Additionally, a small vitrine was added to the room, in order to present rotating displays of material from the archive. During the year between 2014 and 2015, a small group of students from different departments—visual and critical studies, arts administration, art history, design, and sculpture—joined me for a project-based course, to work on a variety of tasks that involved approaching the material as both an archive and research collection.

The project/course was titled "Nodes + Networks: The Publications and Publication Projects of Hans Ulrich Obrist." The overarching theme involved exploring how the documents in the archive represent nodes within a network of human relations. An archive in this respect is not merely a collection of documents or an enumeration of their publication history, but a diverse array of material information that underscores the people, the ideas, and the cultural projects that contributed to the creation of those documents. The project evolved into a way of showing how the documents reflect upon Obrist's curatorial practice of creating links between people, disciplines, venues, and continents—essentially, a practice of hyphenation. The design team was tasked with developing basic design parameters and templates for the project, and creating labels that would be used for

6. Documentation of the first series of exhibitions can be found in the catalogue *MacLean 705*, ed. Joseph Grigely (London: Bedford Press, 2015). Subsequent exhibitions included presentations by Ben Kinmont and Zak Kyes.

MacLean 705, southwest (top) and northwest (bottom) corners, spring 2016

displays and advertising, and for the vitrine exhibitions that took place in MacLean 705. The final design employs two key strategies: the conjunction (+) and the hyphen (-):

Nodes + Networks
The Public-
ations and Public-
ation Projects of Har
Ulrich Obrist

The font used is Univers Condensed Light, which was chosen because it is vertically integrated, like Obrist's handwriting. Additionally, the design team worked on developing templates for the archive box labels, and the project's model of overlapping nodes, which is used as both a visual branding design, and as a model for our hypertextual bibliography. The notion of what constitutes a publication is an expansive one; it includes all forms of the materialization of art and ideas, and each instance of such material form is represented as a node relating to other nodes, all of them collectively comprising Obrist's universe of relationships.

The catalogues, essays, interviews, and related publication genres (sometimes described as "ephemera") typically outlast the exhibitions and curatorial events for which they were designed. These documents are traces of those exhibitions and events, and they challenge us to map the filiation of the individuals and ideas that came together and made these events material forms. The traditional bibliographical model is linear and chronological, and works in a way to sequence textual production, but it does not reflect the sense in which publications are related to specific yet transient events: exhibitions, conferences, and interview situations. A bibliography is fundamentally taxonomic by design as well as utilitarian: it is meant to

order information and to provide a structure that enables this information to be utilized and shared. A conventional bibliographical template might look like this:

> Bibliography of exhibitions curated
> Bibliography of exhibition catalogues
> Bibliography of publications written by HUO
> Bibliography of publications edited by HUO
> Bibliography of interviews conducted by HUO
> Bibliography of talks by HUO

Of particular interest is a category of printed material particularly relevant to contemporary exhibition practices: what I call "exhibition prosthetics." Such material—which includes press releases, announcement cards, catalogues, and public statements—works in a way to expand the reach of an exhibition, by taking it places the exhibition itself does not go.[7] Similarly, some of Obrist's publications are singular by design, such as *Point d'ironie*; sometimes they consist of interventions in existing publications, such as the projects Obrist organized with the museum in progress in Vienna. Does a bibliographer cite these projects as "exhibitions" or as "publications"? Or as both? Bibliography is one of the oldest literary disciplines, and its methodological practices go back to the task of editing Homer's texts in the Library of Alexandria. Centuries of evolved and evolving modes of literary production have informed the discipline's critical tools, in particular the terminology used to describe a work and its filiation—how it relates to other texts, and other versions of the same work, that both preceded and emanated from it. But modern bibliography is poorly equipped to encompass a practice that continually seeks to eschew categorization, and which purposely confronts conventions of curatorial and museum practice. In this case, the encounter with a traditional form of a bibliography offers a format in which to observe Obrist's practice in its singu-

7. Joseph Grigely, *Exhibition Prosthetics* (London: Bedford Press, 2010).

Hans Ulrich Obrist, Joseph Grigely, sign-language interpreter Amy Kisner, and students from the Hans Ulrich Obrist archive research project in MacLean 705, September 2015

larity, and this in its relation to the cultural and artistic practices that he organizes, enables, invites, and encourages. Obrist's oeuvre is therefore critically positioned to contribute to the academic interface between art history and textual criticism.

For guidance in the matter of listing the bibliographical entries we started with the *Chicago Manual of Style,* but in consideration of the unconventional modes of Obrist's publications—particularly intervention projects—it became necessary to emend and expand Chicago's practices. This result was the development of our own in-house style sheet, and all entries to the bibliography follow this style sheet. One important limit to the archive is to confine our attention to printed publications: bibliographical entries are based on firsthand examination of the physical text, and not publisher's catalogues or online descriptions, as secondary sources are prone to frequent errors. Additionally, for practical reasons, the archive does not include Obrist's digital projects, which range from his audio/video archive, to online projects like his handwriting project on Instagram. Obrist's presence on the internet is essentially uncontainable. Capturing and enumerating his digital activity requires a different set of research tools, as well as a different way of thinking about how we quantify visual information.

As part of our project, we organized a series of exhibitions of material from the archive that took place within a vitrine. Sometimes the exhibitions were devoted to a single exhibition/catalogue (such as "The Kitchen Show") or a single series (such as "Migrateurs" in 1993). Some exhibitions were thematic, such as one show on the subject of flight, which brought together Boetti's *Cieli ad alta quota* (1993) with the exhibition catalogue for "Uccelli/Birds" (1996) and related catalogues and texts dealing with Obrist's global mobility, where ideas, art, and artists are in perpetual motion. Another exhibition was devoted to the correspondence between Douglas Gordon and Obrist, focusing on Gordon's text-based art between 1992 and 2002. The exhibitions also

included one project on metadata—a self-reflective appraisal of our archiving practices, in which case we exhibited in the vitrine four boxes and their shipping labels that were used to transport a selection of the archive from London to Chicago between January and October 2014. Each exhibition was accompanied by a label outlining the subject of the exhibition, the contents of the vitrine, and relevant dates. The exhibitions functioned as experiments in the ways one might both display and activate an archive. This approach has precedent in Aby Warburg's "Mnemosyne Atlas"; except that instead of 150 × 200 cm panels on which Warburg arranged seemingly unrelated images, the frame of reference is the volume of the vitrine—150 cm long, 45 cm high, and 50 cm deep.

"Nodes + Networks" is an ongoing project: a "longitudinal" project that simultaneously takes forays into disciplinary experiments with archives, bibliographical methodologies, and the mechanisms of display and representation. There is no closure in the archive; it continues unabated, sometimes at a slow pace, sometimes at a hectic pace, subjecting itself to continuous reassessment about the ways it can be organized and shared.

Meanwhile, the boxes from London continue to arrive at MacLean 705, where they are emptied, sorted, enumerated, and added to the archive. As Arlette Farge has written in *The Allure of the Archives*, "In the end there is no such thing as a simple story, or a settled story"[8]— instead there is a mass of fragments, details, incidents, each publication being a moment in time that does not, for anyone, stay still.

8. Arlette Farge, *The Allure of the Archives*, trans. Thomas Scott-Railton (1989; repr., New Haven, CT: Yale University Press, 2013), 94.

Hans Ulrich Obrist
Flight
1993–2007

Like a traveler making a seamless connection, Obrist's curatorial practice involves mobilizing a global community of artists toward an endless chain of interactions–as if every exhibition is in flight with no decided destination. The selected curatorial projects in this vitrine literalize the idea of flight as a liminal space between arrival and departure, and echo the mobilized spirit of Obrist.

———————

CONTENTS:

1. *Cieli ad Alta Quota*, Puzzle-Set, Alighiero e Boetti. museum in progress, 1993
2. *Travelling Eye*, Hans Ulrich Obrist and Stella Rollig. museum in progress, Vienna, 1996
3. *Fischli/Weiss LA Airport*, EVN-Sammlung: Ankäufe. EVN,1997
4. *Uccelli/Birds*, Hans Ulrich Obrist and Carolyn Christov-Bakargiev. Zerynthia, Paliano-Rome, 1996
5. *Grand escapes: Zurich Road Conversation*. Art Basel, 2008
6. "Cieli ad Alta Quota," *Sky Line Magazine*. Hans Ulrich Obrist, Airline Project by Alighiero e Boetti. museum in progress in conjunction with Austrian Airlines, Vienna, 1993
7. *Airplanes and Parachutes, A Jonathan Napack Anthology*. Art Basel Books 2007

———————

Nodes + Networks
*The Public-
ations and Public-
ation Projects of Hans-
Ulrich Obrist*

"Metadata, January–October 2014," 2014, exhibition view. Metadata describes how, when, and by whom a particular set of data is collected, and how the data is formatted. These boxes contained Obrist's publications between January and October 2014, mailed from London to Chicago, prior to being catalogued.

Afterdeath

Ho Rui An

In 2014, I was invited by Hans Ulrich Obrist to contribute a short presentation for the launch of his new book, *Ways of Curating*, at the Swiss Institute in New York. Reading the text, I decided to show a slideshow of some photographs I took a year ago when I visited his "archive," as he called it, accompanied by my reading of an excerpt from the diaries of the Anglo-German aristocrat, patron, and proto-curator Harry Graf Kessler.

I remember the afternoon in December when I first stepped into the so-called archive housed in a small unit within a nondescript residential building in Berlin. Hans Ulrich was in the midst of one of his peripatetic interviews, the reporter struggling to keep the recorder aimed at his lips as the irrepressible talker (and walker) made his way through the clutter. This was no archive in the strict sense of the term. There was no manner of a catalogue in place, with the mostly printed matter either boxed or piled up like ungainly half monuments to their prolonged neglect. At best, one could call it a collection, though I would prefer to call it a corpus, easily mistaken perhaps for a corpse: partially dismembered, parts without a whole. The enduring image is of stacks of books running over the kitchen stove—such was their indifference to the domestic space!

Rightly so, this assemblage of things can only be consumed in fragments, as Hans Ulrich did, picking up the pieces during our walkthrough: a signed Cy Twombly monograph, Alighiero Boetti's airplane jigsaw, Yoko Ono's *Grapefruit* (1964), a handwritten postcard from Félix González-Torres, a letter of rejection from Jacques Derrida, etc. The last item is fitting, given that it was Derrida who argued that there can be no archive without interior, without domicile, and, in turn, no interior without excess, without an original outside from which the archive encloses upon itself and thereby effaces its remainder. And thus the impossible construction that is an archive *in excess*, that unthinkingly gives itself over to its outside, relinquishing self-preservation for a life in perpetual exile.

Hans Ulrich's excessive archive, by its very existence, turns the archival logic inside out. In it, the archive, this eternal home, this entombment upon which we project our death as "afterlife," remains undead. After all, is it not a miscarriage of thought that we assign to the time after life, a time of radical opening, a word that suggests only more of the same? What else is the eternity promised by "afterlife" but a refusal to reckon with that which truly may or may not come "after"? Against this wishfulness, the impossible archive understands that to live on in the archive, to survive in death as such, is not to enter some eternal resting place, but to live in the persistent temporalization opened by the nonpresence of what comes "after." That is, to live in the *afterdeath*.

Death. The excerpt from Kessler's diaries that I chose to accompany these images of an archive in restless ruin reflects on this very condition. Kessler was a man of such cosmopolitan outlook, whom Hans Ulrich considers among his curatorial forebears. A "junction-maker," as he calls him—mediating between artists, architects, writers, and other intellectuals—a witness and, through his diaries, a record of the lives and deaths of many great European artistic and cultural figures at the turn of the twentieth century. Prompted by the premature death of his old friend and mentor Alighiero Boetti, Hans Ulrich, too, became a compulsive recordist, taping numerous conversations with artists, curators, writers, thinkers, and the like. His lifework, in this sense, is in equal measure a *deathwork*. He tells us in his book that once, in a bid to maximize his waking hours, he tried to emulate Balzac's extreme coffee rituals—up to fifty cups a day—but stopped when he realised that Balzac died young, possibly from caffeine poisoning. Likewise, Kessler's text, which I append here, reminds us that the practice of living is always at the same time a practice in dying.

Before my presentation, I worried aloud about reading a text so grim, so terminal, on the occasion of a launch. To which Hans Ulrich replied, "But this is perfect. I think about death all the time!"

Paris, October 12, 1909. Tuesday.

Visited Rilke in the afternoon in his beautiful, princely rooms in the Hotel de Biron, next to Rodin. Through the large casement windows you saw the garden in the autumn light. Rilke sat there, weak and shivering, despite the warm autumn sun. He wants to give these rooms up. They have collected so many sad memories for him, he's been sick in them so often, and so often unable to work, that now it's as if spider webs covered him. The previous winter here was so bad for him, in part physically, in part psychically. So many things that he thought he knew had shown him another side that his entire world had been rocked, so to speak.

As one of the things that changed for him, he named Rodin. I: "In what way?" Rilke: "Yes, so much that I had thought to have discovered in him proved to be false. I see so much now about him in a completely different light." I: "His art" Rilke: "Yes, even his art." I: "So, his life?" Rilke: "Yes, things in his life. You see, when I was around him so much several years ago, then he seemed to me to be a living example for how an artist growing old could be beautiful. I knew that, or believed to know it, from the example of Leonardo, Titian, etc., but Rodin for me was the living proof. I said to myself, So I too would like to become old in beauty. And then it suddenly turned out that growing old is something terrible for him, exactly as terrible as for your average person. He is *bored*. Now when he cannot fill his entire day with his enormous works, he's bored. One day he came here to me in the studio and said to me, "I am bored." And how he said it, I saw how he observed me, how he peeked secretly—almost frightened—to see what kind of impression this confession would make on me. He was bored and seemed not to be able to understand it himself. And this boredom had something frightening, because now, due to it, other things became important for him, which up to then had vanished before his enormous appetite for work. And he took these things, not as

one would expect from Rodin, but exactly as one would expect from any other old Frenchman."

I: "The women?" Rilke: "Yes, the women and other things as well, which I had always assumed he had somehow taken care of in his life a long time ago, given them a certain fixed place. Now it suddenly turned out that he had not even thought about these things before. So he came running to me here one day, seized by a nameless fear of death. Death, he had never even thought of death! Things that I had assumed he had made his peace with thirty years ago have now seized him for the first time, when he's old and no longer has the energy to be rid of them. And so he looked to me, the young person, for help with his nameless fear of the idea of death!

"Some years ago it was still different. The first time he spoke to me about death was in Meudon. We stood leaning on a balustrade and looking at the valley below. Then he said he couldn't grasp it that now when he had finally learned how to work, that this work would suddenly stop one day. That didn't seem possible to him. Then it was still the sorrow for his work that must be interrupted, so something noble, that moved him. Now, however, it is the pale, naked fear of death, without anything consoling about it. His entire immense work, in which he, as I believed, had come to terms with all things, now represents just the opposite, an obstacle, something that leaves him no time to think seriously about these things, about death, about women, without the time to find some kind of firm relation to sensuality. These things so overwhelm him now when he can no longer work so hard, when he suddenly has free time, and so everything has become for him a horror."

Excerpt from Harry Kessler, *Journey to the Abyss: The Diaries of Count Harry Kessler, 1880–1918*, ed. and trans. Laird M. Easton (New York: Knopf, 2011), 495–96.

Yoko Ono

He is a passionate communicator.
In result, half the world is starting
to live in the future now.

"Infinite Conversation" or The Interview as an Art Form*

Michael Diers

"Infinite Conversation"

> *Monday, August 21, 1978*
> It was such a pretty day. Hot and dry and breezy.
> Started walking downtown handing out *Interviews*
> over on the East Side.
> —*The Andy Warhol Diaries*

"In One's Own Words"

Over the last three decades, the literary genre of the interview has had a rather unusual career in the visual arts, and judging by contemporary practice, one might consider it to be the preferred textual format of art criticism. For quite some time now, interviews have been an integral part of art magazines, and the format has assumed an authoritative voice in the contemporary art world, while it has also become fashionable. This trend seems to be perfectly in sync with a society of conversation that practically worships any form of public utterance. Under the media's pressure for publicity and publication, any given opportunity to draw a microphone and to turn on the cameras is seized.

*The first part of the title refers to the English title of the book *L'entretien infini* (1969) by Maurice Blanchot, which Hans Ulrich Obrist quotes often to characterize his interview project. See Maurice Blanchot, *The Infinite Conversation*, trans. Susan Hanson (Minneapolis: University of Minnesota Press, 1992). I would like to thank Hans Ulrich Obrist for the numerous private and public conversations we had about his interview project, most recently on the occasion of the conference "Kunstgeschichte der Gegenwart schreiben" (Writing art history of the present), held by the Vereinigung der Kunsthistorikerinnen und Kunsthistoriker in der Schweiz (VKKS) and the Swiss chapter of the International Association of Art Critics (AICA) in Winterthur, Switzerland, October 2002; on the occasion of the lecture series "Kunst der Gegenwart" (Contemporary art) at the Staatliche Hochschule für Gestaltung, Karlsruhe, January 2003; and the section "KunstGeschichte und GegewartsKunst" (Art history and contemporary art), of the 27th Deutscher Kunsthistorikertag, Leipzig, March 2003.

[Unless otherwise noted, all translations are Diers's. The text remains only slightly modified from its original version, which refers at times to the book it was published in: Hans Ulrich Obrist, *Interviews: Volume 1*, ed. Thomas Boutoux (Milan: Edizioni Charta, 2003). Updates and clarifications can be found in the brackets.—Ed.]

The desire for audiovisual recording transmits well into the private sphere and is continuously stimulated by the ever smaller and more convenient equipment provided by the home electronics industry. Recorders and empty tapes ask to be put to use, an increasing number of channels require transmission. The technology of visual media, above all television, have unexpectedly empowered the act of speech and the spoken word and have elevated it above the written word and text, while the excess of supply has simultaneously devalued it. Talk shows, statements, and interviews on the most arcane of topics occur in epidemic proliferation and, as a form of public rhetoric, are of central significance to the society of the (media) spectacle that Guy Debord described.

Andy Warhol has programmatically made the interview acceptable for contemporary art. Founded by Warhol and the members of his factory, his magazine *inter/View*[1] first appeared in fall 1969, and was meant to be "a monthly film journal": "Our journal *Interview* came out of an interest for the history of fashion and society and for entertainment. We did not just want to go to dinner parties, by no means. And Andy also constantly records everything on tape and film. He basically only does what many artists before him have done, like Marcel Proust, for instance."[2] Warhol's magazine project aimed both in the direction of prominence and in that of the audience. While it supplied readers with informative entertainment, it provided a platform for the (film) stars to "*just talk*—[in] *their own words*, unedited—and, wherever possible, to be interviewed by other stars. This was something new in magazine publishing."[3] The famous artist

1. This was the spelling of the magazine's title for the first issues.
2. Robert Colacello, quoted in Bice Curiger, "Alles ist viel zu ernst— Interview mit Andy Warhol," in *Kunst expansiv—Zwischen Gegenkultur und Museum* (Regensburg: Lindinger & Schmid, 2002), 135.
3. Pat Hackett, introduction to Andy Warhol, *The Andy Warhol Diaries*, ed. Pat Hackett (New York: Warner Books, 1989), xii. My emphasis.

replaced the traditional reporter: Warhol himself, accompanied by an editorial staff member, initially conducted interviews. The idea was to enable a conversation among equals—no journalist would torture the interviewee with stupid questions;[4] instead, one could talk in a relaxed atmosphere, often over a good meal.[5]

But Warhol's magazine stands only for the presentation and production sides of an interview practice that during the 1960s was developed mainly by artists themselves. Necessitated by the distance and lack of understanding that art criticism exposed in relation to the most recent art of their times, artists like Carl Andre, Donald Judd, or Robert Morris took the explanation of their work into their own hands. The restrictions associated with the critics' and curators' roles as "gatekeepers"[6] ultimately forced the artists to "fill the discursive gap with self presentations in interviews as well as conceptualizations of contemporary tendencies."[7] However, this self-empowerment of the artists associated with Pop, Minimal, and Conceptual art was not always well

4. Cf. the hideously failed interview between Warhol and an unnamed German journalist that Warhol published as a caricature in his *Index (Book)*: "German Reporter: You are a difficult subject to interview, because ... Andy [Warhol]: I told you, I don't say much. German Reporter: Yah, I know, talk is very little, doing is everything. Andy: Yes. German Reporter: You don't want to talk at all ... Andy: Eh. No. ... German Reporter: You said that you're willing to talk to me. And obviously, since you were nice enough to say, well, okay, we'll talk, that I would ask you questions, and that the questions would be more or less that I would like a definition of Andy Warhol, because I wouldn't want to define you, I would rather have a definition of you about yourself and the role you think you are playing among young people, because they are flocking to you. They are adoring you. They love you. I know that because I have talked to many. This is what interests me and it interests me what it does to you. Andy: [Nothing]." Andy Warhol, "An Interview with Andy at the Balloon Farm," in *Andy Warhol's Index (Book)* (New York: Black Star Books, 1967), n.p.

5. See Curiger, "Alles ist viel zu ernst," 129.

6. Lawrence Alloway, "Artists as Writers, Part Two: The Realm of Language," *Artforum*, April 1974, 33, 35.

7. Thomas Dreher, "Interview Yourself! Amy Alexander," IASLonline Lektionen in Net Art, 2001–2, http://iasl.uni-muenchen.de/links /lektion9.html. This very informative article provides a good overview of the topic.

received by the critics, as it raised their concern that artists from now on would rather speak than create.[8]

But the sheer quantity and ubiquity of published "conversations with artists" also raised a more serious critical response. Already in 1972, Lawrence Alloway voiced his skepticism with the growing popularity of the artist's interview, especially as it concerns the disparity of the conversation's context and the threatened independence of the interviewer. For only too often, the artists use the interview as a means to steer the conversation and to bias the critic: "The failure to interpret has left us with a backlog of unevaluated interviews. [...] Contact with the artist can produce information of an accuracy impossible to achieve in another way, but it can also inhibit writers from taking the discussion in directions that the artists resist or have not thought of. If the critic's interpretations are bound by the intentions of the artist, there is a corresponding neglect of comparative and historical information."[9]

But the interview's proponents are equally ready to stress the particular advantages of the format. Saul Ostrow, art editor of *BOMB* magazine (which is celebrated for its interviews), champions the format for allowing emerging and established artists alike "to publicly voice their views," to critically reflect on their own body of work and its reception, and to supply "readers of *BOMB* magazine with raw material from which to draw their own conclusions."[10] And his colleague Betsy Sussler, a founder of *BOMB*, adds in regard to the qualities of the genre: "The interview is a form unto itself.

8. Cf. the title of the introductory essay to the German edition of Andy Warhol's diaries, *Andy Warhol, Das Tagebuch,* ed. Pat Hackett (Munich: Droemer Knaur, 1989), 7. Alfred Nemeczeck improvises on Goethe's famous saying, "Bilde Künstler, rede nicht!" (Create, artist; do not talk!) when he writes, "As the artist no longer had anything to say, he began to talk."

9. Lawrence Alloway, "Network: The Art World Described as a System," *Artforum,* December 1972, 31.

10. Saul Ostrow, introduction to *Speak Art!: The Best of BOMB Magazine's Interviews with Artists,* ed. Betsy Sussler (New York: G&B Arts International, 1997), xiii.

While questions can be prepared, and the artist's work researched, what takes place in conversation happens spontaneously, and cannot be scripted; queries arise from responses, ideas are circled and searched for. While conversations often can seem elliptical or tangential, there is always, embedded in the transcript, a thread, a rhythm, a subtext, and an interior logic."[11]

While Alloway, Ostrow, and Sussler ponder the advantages and disadvantages of the format, Russian curator and critic Olia Lialina strictly rejects the interview as a kind of uncritical homage. In an entry on the newsgroup mailing list Nettime, she writes: "The interview approach cultivates stars, not ideas."[12] But her general skepticism also disavows those standards and possibilities achieved by Warhol and the Minimal and Conceptual artists. The Californian artist Amy Alexander has given a rather different, self-referential spin to one of her works. For her *Interview Yourself* project, she invited peers and colleagues to "self-interview" themselves.[13] *Interview Yourself* reacts to art critics' engagement with Net art, which has been limited or entirely missing. She creates a public sphere in which the artists can present their own projects, approaches, and theories, and invites artists to interview themselves. The artists can select the questions they consider most appropriate for the understanding of their work and the presentation of their concepts.[14] This might be seen as making a virtue of necessity, but it also reduces the potential dialogue to a soliloquy and thus either points to its final and inherent limits or renders it entirely absurd.

11. Betsy Sussler, editor's preface to *Speak Art!*, ix.

12. Olia Lialina, quoted in Dreher, "Interview Yourself!"

13. Cf. Tracey Emin's self-interview in her video *The Interview* (1999); it is no coincidence that her work has been described as "confessional art."

14. Dreher, "Interview Yourself!" Cf. Amy Alexander's interview platform Plagiarist: http://plagiarist.org/iy.

There is in fact no better way to learn about this art
[painting] than to speak often with those people that
are knowledgeable about it.

—André Félibien[15]

"Inter-view"[16]

The term interview originally designated the journalistic
and published format of interrogating a contemporary.[17]
It paradoxically constitutes what could be called a one-
sided conversation, as it usually excludes alternating
speech, or dialogue, and remains reduced to the structure
of question and answer. The German etymological diction-
ary offers a rather helpful definition by concluding that the
"interview is a conversation between a [newspaper] jour-
nalist and a figure from public life about a current event
or another topic that is of particular interest because of
the person interviewed." It further specifies that "inter-
view" is an American English word, which was appropri-
ated into the general vocabulary from journalistic
nomenclature in the late 1800s and which itself derives
from the French term *entrevue*, meaning "arranged
encounter." The French verb *entrevoir*, which is the root
of the term, means,"to see each other at close distance,"
"to meet each other," and "to encounter," and is itself a
neologism of the French word *voir* "to see" (cf. the Latin
videre).[18] The terminology's focus on the visual rather than
the vocal aspects emphasizes the moment of encounter
rather than the act of talking, which has to be imagined

15. André Félibien, *Entretiens sur les vies et sur les ouvrages des plus
excellens peintres anciens et modernes* (Paris, 1666). Cf. Louis Marin, *De
l'entretien* (Paris: Éditions de Minuit, 1997).

16. Hans Ulrich Obrist, in *Hans Peter Feldmann—272 Pages*, ed. Helena
Tatay (Barcelona: Fundació Tàpies, 2001), 238.

17. "The interview is a journalistic questioning with the purpose
of rendering a current news topic as a personal report in the form of
a conversation. Its attraction lies in the personal connection, its art in
the animated account." Emil Dovifat, "Interview," in *Zeitungslehre*, vol. 1
(Berlin: De Gruyter, 1968), 28.

18. *Der große Duden: Etymologie; Herkunftswörterbuch der deutschen
Sprache* (Mannheim: Bibliographisches Institut, 1963), 290–91.

as an exchange of conventional courtesies and at best as "conversation," a term that well into the sixteenth century was defined merely as "keeping company" and not as a form of dialogue.[19]

The technique of the interview, elevated from the realm of journalism, has become a scholarly method used in the social sciences, history, cultural studies, and even psycho-analysis, is based on a more elaborate form of interroga-tion.[20] Usually it is used to collect information given in oral testimony and make it available in transcribed or recorded form, either as a statement, report, or narrative. Authen-ticity, authority, and subjectivity are central qualities of this form of documentation. The relevant information collected in this way can be considered a source, which can be quoted and referred to as supporting evidence.

The interview is part of the category of statements. Its history, as well as the history of the artist's interview, remains to be written, even though its importance for the history of art and art theory would grant a more thorough study by now.[21] Such a study would have to consider the prehistory of the artist interview, which dates back to the earliest recorded artists' statements, often disguised in the form of anecdotes, legends, and biographic reports.[22] And as art history develops a historical self-consciousness and begins to form itself as a discipline, they are collected in

19. Cf. Claudia Schmölders, *Die Kunst des Gesprächs: Texte zur Geschichte der europäischen Konversationstheorie* (Munich: dtv, 1979), 25.

20. While the conversation may be considered as one side of the *dispositif* of the interview, the (criminal) interrogation may be seen as the other side.

21. I am grateful to Peter J. Schneemann, who informed me of the unpublished thesis text by Christoph Lichtin on the "conversation with the artist," "Das Künstlerinterview: Analyse eines Kunstproduktes" (PhD diss., University of Bern, 2002), which I unfortunately was unable to read. [Lichtin's thesis was published under the same title by Peter Lang in 2004.] Louis Marin's small book *De l'entretien* (see note 15) follows a different concept.

22. See the well-known study by Ernst Kris and Otto Kurz, *Legend, Myth, and Magic in the Image of the Artist: A Historical Experiment*, trans. Alastair Laing (New Haven, CT: Yale University Press, 1979). This book is based on the German text from 1934, and was expanded by Otto Kurz. Cf. Martin Warnke, *The Court Artist: On the Ancestry of the Modern Artist*, trans. David McLintock (Cambridge: Cambridge University Press, 1993).

voluminous tomes and anthologies, which, like Giorgio
Vasari's *Lives of the Most Eminent Painters, Sculptors, and
Architects* (1550), are used as references to this day.[23] These
collections of biographies and work reports do present an
almost inexhaustible source, even though their historical
veracity should not be overestimated. Vasari, an artist
himself, began his extensive enterprise to recount the
history of art "until the present day" and his elaborations,
spanning almost three centuries, finally end with contem-
poraries, covering artists like Michelangelo (Buonarroti),
Titian (Tiziano Vecelli), Jacopo Sansovino, Giulio Clovio,
as well as his colleagues from the Florentine Academy like
Bronzino, and—last but not least—himself.[24] It is reported
that for his book, Vasari, like an art historian, "had to
travel long distances, study remote sources and inscrip-
tions, consult archives, and maintain a vivid correspond-
ence with many humanists and local historians [...] in order
to give a historical perspective to the right of art to resist
its cooptation through its independence."[25] It is safe to
assume that as he was moving into his own period, Vasari
also conducted conversations with his peers—although
probably not structured as interviews—and included the
outcome into his *Lives* wherever he felt compelled to do so.

Two examples of such studio conversations come to
mind. In both instances Titian is at the center, one time
in Venice, the other in Rome. Vasari reports from Venice:
"When Vasari, the writer of this history, was at Venice
in the year 1566, he went to visit Tiziano, as one who
was much his friend, and found him at his painting with
brushes in his hand, although he was very old; and he had
much pleasure in seeing him and discoursing with him."[26]
And from Rome comes the following report: Michelangelo
"and Vasari, going one day to visit Tiziano in the Belvedere,

23. Giorgio Vasari, *Lives of the Most Eminent Painters, Sculptors, and
Architects*, trans. Gaston Duc du Vere, 10 vols. (London: Macmillan, 1912–13).
24. See Vasari, *Lives*, vol. 10.
25. Martin Warnke, "Der Vater der Kunstgeschichte: Giorgio Vasari,"
in *Künstler, Kunsthistoriker, Museen: Beiträge zu einer kritischen Kunstgeschichte*,
ed. Heinrich Klotz (Lucerne: C. J. Bucher, 1979), 21.
26. See Vasari, *Lives*, 9: 178.

saw in a picture that he had executed at that time a nude woman representing Danaë [...] and they praised it much as one does in the painter's presence. After they had left him, discoursing of Tiziano's method, Buonarroti commended it [...], saying that his colouring and his manner much pleased him, but that it was a pity that in Venice men did not learn to draw well from the beginning."[27] Such remarks occur during a conversation among artists and can be seen as theorems and statements on equal footing with the kinds of statements made in a modern-day interview. And it is not difficult to imagine Vasari equipped with a microphone and a tape recorder (or even a video camera).

It is the merit of Annibale Caro, whom Vasari had asked to give some friendly advice and editorial help, to render the conversational character of such remarks visible. In a letter written to Vasari, he particularly focuses on this quality: "For a work like this, the author should attempt to write *as if he is speaking*, and he should always use a simple expression and keep a distance to metaphors, affectation, and everything foreign."[28] The particular oral status that also characterizes the interview is thus again emphasized.[29]

27. Vasari, 170–71.
28. Annibale Caro in a letter to Girogio Vasari, December 11, 1547. This letter is excerpted in a footnote in both the Italian and German versions of Vasari's *Lives*. Unfortunately, no English version contains this footnote, and it is thus translated from the German quote, under close comparison with the original Italian. The corresponding page in the English edition would be Vasari, *Lives*, 10: 196–97. My emphasis.
29. It is the rule that orally conducted interviews (with artists) are edited for publication. Julia Gelshorn has recently confirmed this for the artist Gerhard Richter by documenting his minutely detailed editing process of an interview, in "Der Künstler spricht: Vom Umgang mit den Texten Gerhard Richters," paper presented at "Kunstgeschichte der Gegenwart schreiben," Internationale Tagung der VKKS, Winterthur, October 2002; a publication documenting the conference is in preparation [later published as *Legitimationen: Künstlerinnen und Künstler als Autoritäten der Gegenwartskunst*, ed. Julia Gelshorn (Bern: Peter Lang, 2005)]. The Swiss artist Thomas Hirschhorn has also remarked on the burden of reworking his interviews; he would always have to "rewrite everything, because I am so dissatisfied with the interviews (my answers, of course)." Quoted in Ursula Arx, "Was soll der Professor sagen, Herr Hirschhorn?," *NZZ Folio*, October 2002, 9.

Michael Diers

The studio visit is not only an iconographic trope of art history, but also a trope in the history of the "conversation with the artist."[30] Already in 1940, the Swiss art historian Heinrich Wölfflin stressed the importance of the conversation with the artist in understanding art and the concept of one's own discipline: "For whoever visited the artists' studios has experienced the deep trench that exists between the historians of art and the 'experts' of art working here; this is understandable, given that both groups talk about the same thing in very different languages. I believe that we have to begin here and attempt to illuminate the specificities of artistic achievement."[31] Wölfflin himself made these studio visits only very hesitantly and dedicated himself firstly to the history of art (and thus the general principles) and engaged the more current art only much later. The reason for his failure to follow his original plan was that "one first had to understand the general before one could engage with the particular." For a long time, art history mainly maintained the "conversation about art,"[32] while the "conversation with the artist" was avoided, even though Vasari, the "father of art history," had provided such a great example when he founded the principles of the discipline. The conversations about art were mainly conducted among philosophers, historians, and connoisseurs, while artists

30. A brochure of the Akademie der Staatlichen Museen zu Berlin announcing the classes for the winter semester 2002–3 listed a class with the title "Kunst jetzt: Aktuelle Positionen der zeitgenössischen Kunst" (Art now: Current trends in contemporary art). It listed conversations with artists and studio visits as part of the class program, and further explained: "The question What is art? has to be answered anew every week, as there are no defined criteria for the approach of contemporary art, and sometimes the artists themselves have to answer this question as well."

31. Heinrich Wölfflin, *Gedanken zur Kunstgeschichte: Gedrucktes und Ungedrucktes* (Basel: Schwabe Verlag, 1941), 1.

32. Compare, for instance, the title of the magnificent work by André Félibien, *Entretiens sur les vies et sur les ouvrages des plus excellens peintres anciens et modernes*, or Louis Marin's *De l'entretien*, which was translated into German by Bernhard Nessler as *Über das Kunstgespräch* (Zurich: diaphanes, 2001). (The French term *entretien*, of course, means conversation, talk, or interview. The German title, meaning "the talk about art," stands in clear distinction to the term *das Künstlergespräch*, meaning "the artist talk.")

generally remained excluded. One important exception is *Entretiens sur les vies et sur les ouvrages des plus excellens peintres anciens et modernes* (1666) by the French court architect and historiographer André Félibien, which is a collection based on conversations with his friend, the painter Nicolas Poussin. But more recent art history has preferred to interpret simply the artworks and the statements embedded within them.[33]

This approach is not only valid for more classical art, it also works for contemporary art as well, as Robert Rauschenberg demonstrated with one of his early combine paintings, entitled *Interview* (1955), which gives concrete artistic form to the theme. The rectilinear, vertical combine painting is split into two by a movable white door. Resembling a baroque *Wunderkammer*, heterogeneous objects, like boxes and bins, a rock, a baseball, several fabrics, and images in every conceivable facet are combined. The title *Interview* might allude to the opened artist's studio, into which we are granted a view, mediated by the autobiographical shrine. The conversation is not conducted directly, but rather is mediated through objects and images that besides their more general meaning uphold a very personal one, which is given access to by means of a "silent conversation" with the viewer during an imaginary visit to the studio.[34] In a conversation between Hans Ulrich Obrist and Douglas Gordon, Gordon says that "art is really an excuse to have a dialogue."[35]

33. Cf. Matthias Winner, ed., *Der Künstler über sich in seinem Werk: Internationales Symposium der Bibliotheca Hertziana Rom 1989* (Weinheim: VCH, 1992).

34. For more about the painting, see Roni Feinstein, *Robert Rauschenberg: The Silkscreen Paintings 1962–64* (New York: Whitney Museum of American Art, 1990), 23–24.

35. Douglas Gordon in Hans Ulrich Obrist, *Interviews: Volume I*, 323.

"Dear Hans Peter [Feldmann],
As the interview book grows, so do the doubts
about the format in general. Gadamer said to me
that one big problem with interviews is that you
can't transcribe the silences.
Best Regards,
Hans Ulrich [Obrist]"[36]

Art Form

Hans Ulrich Obrist's interview project is cast from a very
unusual, individual mold. It is neither a journalistic nor a
scholarly enterprise, but it rather follows an encyclopedic-
philosophical model, based on a very emphatically under-
stood concept of the conversation as a fruitful/successful
exchange of ideas and exemplified in the form of the
interview. This encyclopedic character is less a product
of the sheer number of existing interviews,[37] but rather
an outcome of the manner in which the interviews were
conducted and of the range of professions, both from
science and art, represented by the interlocutors. Start-
ing from a series of interviews with artists that Obrist
conducted in the early 1990s for the museum in progress
in Vienna,[38] the circle of those interviewed has increas-
ingly widened internationally and now includes curators
and museum professionals, art historians and critics,

36. Obrist, *Hans Peter Feldmann*, 238.
37. To date [2003], there are about four hundred interviews in
the archive.
38. Cf. the video editions in the series "Künstlerporträt" (Portraits
of artists, 1992–2001), a discussion series with internationally renowed
artists, conceived by Peter Kogler with the museum in progress, Vienna.
From a 2003 catalogue at Barbara Wien Gallery and Bookstore, Berlin:
"Self presentations and authentic statements by the artists. They
select their interview partner and edit the video themselves." See also
the monograph about the video series, *KünstlerInnen: 50 Positionen
zeitgenössischer internationaler Kunst* (Cologne: Kunsthaus Bregenz, 1997).

writers, filmmakers, and photographers, philosophers and scientists, architects and urbanists. Most conversations originated from concrete work relations and commonly have friendly relations at their basis. In his function as curator and organizer, Obrist has traveled around the world and has come into contact with countless individuals. He has used every possible and impossible occasion—in airplanes, taxis, boats, and elevators, on the phone, by email, or by fax, in one or in several installments—to conduct his interviews, always recorded on tape or on video (except for in the case of Gabriel Orozco, who maintained that his interview with Obrist should not be recorded; Hans Ulrich was only able to take notes during their meetings). Douglas Gordon emphasized the influence of the conditions of modern everyday life on the conversations:

> I really think that the difference between our generation and other generations is that it's not even a flow of images that we have to deal with, or a flow of information—it's a deluge, and I think probably the way this interview is going is absolutely indicative—there are so many other things happening [...]. Since we came into this flat, where we are having a conversation with each other, and while we are talking in real time we are remembering what happened five minutes ago, we are anticipating the next question, we can hear the roadwork outside, there is a TV here, there is the telephone ringing, there is music playing—but we can handle this as human beings. But this is very late late-twentieth century. I think this is absolutely not the way that someone like Broodthaers could live, or someone like Duchamp could live.[39]

These conversations are rarely scheduled or planned and are most commonly conducted as a byproduct of another event. Sometimes they even expand from a dialogue to

39. Gordon, in Obrist, *Interviews: Volume I*, 323.

a trialogue. Obrist is a passionate conversationalist, mainly because of his personal desire to find out more about a given subject or a certain position, often inspired by an essay, a book, or an artwork. He is full of questions and his search for answers brings him into contact with those recognized as experts in the different fields. Questions initiate a collaborative reflection, and soon the interview has given way to a normal conversation.

It was Hans-Georg Gadamer who said that the secret to a good conversation lies in the questions.[40] And Hans Ulrich Obrist's reason to interview this philosopher—in an act of self-reflection about his own practice of communication and interrogation—may be seen in his desire to consult a conversation expert on the historical and general dimensions of this art of verbal (ex)change. According to Gadamer, the conversation is the main form of communication and the oral word assumes priority over the written word precisely because the modulating qualities of the voice are especially successful in joining the rational element together with the emotional. Naturally, transcription loses many of these advantages, but a small solace might be derived from the fact that the original recordings remain stored.

Obrist's *Interviews: Volume 1* is a sourcebook that brings together different authors and positions, from Abramović to Zeitlinger. However, it is also a reader that enables a trip around the world in eighty conversations, as much as art, architecture, literature, film, photography, and systems of thought are able to portray it adequately. And it is further a portrait album that among those interviewed also renders visible the interviewer. Its litmus test is a definition by Sigmar Polke: "An interview is good when it has an own internal logic, when it becomes an art form."[41]

Each individual interview in this anthology remains legible in its own right, but also enters a larger context, which could be described by J. G. Ballard as

40. Hans-Georg Gadamer, in Obrist, *Interviews: Volume I*, 244.
41. Sigmar Polke, "Ein Bild ist an sich schon eine Gemeinheit," interview by Bice Curiger, *Parkett*, no. 25 (1990): 15.

"a laboratory for interdisciplinary dialogues"[42] and with Hans Ulrich Obrist as part of an infinite conversation. The idea of the laboratory stressed the space for tests, concepts, and thought experiments, and the infinite conversation refers to Maurice Blanchot's book of the same title. Historically, it goes back to the concept of German Romanticism that a conversation will never reach an end, for it will always only approximate its subject and therefore always requires to be continued.

42. J. G. Ballard, in Obrist, *Interviews: Volume I*, 61.

On
Interviews

Douglas Coupland

I've only ever interviewed one person—that was Morrissey, in Rome, January 2006. I *almost* came close to interviewing Martin Amis in 2000 when he was passing through Vancouver on a book tour for his memoirs, titled *Experience*. I agreed to do it because, well, it's Martin Amis. And for once I'd be able to feel what it was like to be the interrogator. Since 1991 I'd been on the other end of the interview process and now the shoe could be on the other foot. I read his memoirs and I wrote up a list of questions. This was harder to do than I thought because suddenly the experience felt like a high school homework assignment, and the moment that happens to me, it no longer feels like writing; it feels like ... *homework,* and I hate and resent doing it. The clock was ticking. At one o'clock I was going to be sitting in a room with Martin Amis. So I was fucked.

I cobbled together a list of questions and showed up at a Japanese restaurant downtown. Vancouver had just passed a no-smoking bylaw. But Mr. Amis would only do the interview in a room in which he could smoke. There was an embarrassing prelude to set up a clandestine smoking room—which was slightly rock-star, but not enough so to overcome the annoyance factor. Everyone was running around feeling as if an alien invasion was about to occur, with lookouts posted on all doors.

And then Martin Amis came into the room, looking travel-worn and crabby, and said to me, "You're really not going to go through with this, are you?" I said, "No," feeling like I'd just gotten off the hook in the best sort of way. He then asked if we could go buy some pot, so we went to score from a friend and Mr. Amis ended up having an interview-free and very pleasant afternoon down by the harbor.

Morrissey was different. It was for a UK weekend magazine and they wanted to know if I'd like to get paid a shameful amount of money to fly to Rome in first class to interview *Morrissey.* Now, let us remind ourselves that life doesn't throw us ambrosial gigs like this too often. If you have to do one interview in your life, it might as

well be with someone worth being intimidated by, involve
flying to Rome in first class and staying at a five-star hotel
beside the Piazza del Popolo. I decided to say yes, and
I prepared for the trip, which included asking my doctor
for some of these new-generation sleeping pills that waft
you away into gentle REM sleep atop a cloud of frolicking
kittens and puppies. No problem. So I took one of these
pills on the plane to Frankfurt and had a mild sleep.
I took another one at Rome's Leonardo da Vinci Airport
when I arrived—but it didn't do much, so I took another
and fell asleep around 9:00 p.m. I woke up at 5:00 a.m.,
far too early to do anything. I popped one more sleeping
pill and woke up around 11:00 a.m. feeling lucid and
confident. But the interview was still eight hours away.
I walked around the city feeling marvelously alert, as
if in that pleasant fugue state that immediately precedes
the onset of a flu, drinking large amounts of strong
Italian coffee to heighten the sensation.

Later in the afternoon back at the hotel room I got
a call. Morrissey was bored and wondered if we could
do the interview right then. *Bored?* What could be more
Morrissey than peevish boredom?

Fine. I went down to the hotel bar to meet the man
who has written huge chunks of music that have defined
much of my life for over a decade. I was shown in, and
there he was at the banquet table, but the only thing
I could notice is how disproportionately large his head
was—not just slightly large, but medically, clinically, two
times as large as it ought to have been for the size of his
body. I was asked to sit down, and then I remember being
on the phone talking with my agent about six hours later,
and realizing—*Wait ... what time is it? Huh? What the ...?*—
and I had no memory of the Morrissey interview at all
except (and I have no idea what this means) that I had
been talking about monsters, specifically from the *Creature
from the Black Lagoon* and ... *uh-oh.* The fact remained I
had to write the magazine article (which I did)—the jour-
nalistic equivalent of looking into a near empty fridge
and somehow managing to whip up a passable omelet.

Dear Morrissey, if you're out there and you're reading
this, please accept my apologies, and please, should
our paths ever cross, please tell me what on earth I was
talking about in Rome and, oh, please understand that
I am not normally a babbling free-associating random
person—quite the opposite! Things went slightly off the
rails. I blame jet travel and new-generation sleeping pills.

Truth be told, on the plane to Frankfurt, I felt like
a small-town Mississippi cop being given a wide variety
of torture implements with no supervision or instruc-
tions on how to use them. And that's largely what most
interviewing is like. The interviewee sits there and,
in exchange for nebulous benefits, allows a stranger
to come in, pull their pants down and attach probes
to their body, all the while tacitly complying to politely
respond to rude or thoughtless questions, as they squelch
their true thoughts and feelings, all to come off, in the
end, as a mildly generic blank.

A few years ago for one semester I taught a fourth-
year class at Vancouver's Emily Carr University of Art
and Design. It was on print media, and after a few sessions
we got to the subject of fame and what it means. I asked
the students what they thought the best thing about
being famous would be, and their response completely
floored me: *that they would get to be interviewed.* Good Lord,
talk about being careful what you wish for. There was
no way of convincing them that interviews can be nasty,
ugly, brutal experiences— bordering on mind rape—with
hazy benefits, usually "publicity." *Ugh.*

My first interview ever was with the *LA Times*—a good
start. But I had the one publisher on earth who, when
looking at my increasing books sales, instead of saying,
"Let's capitalize on this," instead said, "This trend can't
possibly last, so please, arrange no more interviews for
this Coupland, whoever he may be." So, at the one point
in my life when interviews would actually have been
really helpful, I was abandoned by said publisher.

That was in the old days of interviews: phone calls
and tape recorders that always died or had no replace-

ment batteries; synchronized phone calls at odd times of day and night; little, if any, help from the publisher in dealing with wackos and crazies. There were no blogs or fan-sites or websites or ... anything. It was pre-everything. God, I can't believe how primitive it all was, how low-tech and dismal. There was also a cachet about "the interview" back then. It was one of the few ways in which a person might learn something about someone else. The results were much more important because they'd be "on the record" and available to people who paid an extortionate amount of money to do LexisNexis searches.

My own interview policy is to never read anything written about myself, good or bad, because if you believe the good, then you also have to believe the bad, and you can become a sort of lost-inside-the-mirrors person like Courtney Love who scours the planet pursuing every press molecule that might exist. I ask the people in my life to read what there is, and if there's something unusual, they'll pass the nugget along, but that's as far as it goes.

Once, in 1995, I was visiting Ireland where my cousin lives. I did an interview in Dublin with this guy from the *Irish Times* where I got way too drunk and went into alarming detail about every demon within me—to the point where I felt I'd become a lifelong friend with the interviewer. A week later, when my cousin called to ask about the interview in the paper that day, my heart sank and I knew I was in deep shit. Instead my cousin asked what exactly I talked about—so I told her—and she asked, "Are you sure?" She faxed me (yes, faxed!) the article. I read it. The writer had simply invented an interview with me. Every single quote and anecdote was fabricated. It was as if we had never met. So that's when I decided that I'd had enough with old-style interviews— and enter digital technology circa 1995.

That's when I knew there was a shift coming. I was using AOL's email service (I know) and I realized that when you do a Q and A interview online, there's no misquoting, the answers actually reflect reflection, and it makes for a better, truer, read. From the writer's

perspective it's a bonus because the thing literally writes itself. I began to press for email interviews (nowadays we say "online interviews") and was actually getting somewhere until Duran Duran set the entire email interview process back five years by having a publicist answer questions as "them." Thanks guys. It was not until 2000 when newspapers with slashed budgets realized that they could save money by doing online interviews, and this process has been accelerating to the point where, now, they are finally the norm. If you google my name along with "Q and A" you'll be inundated with innumerable interviews done largely since 1998. Will you learn anything about me? Yes. No. I'm a hard interview because I'm too aware of the process and I have no tolerance for boring questions, for reanswering a question I know I've addressed many times before, or for clueless people in general. *Get to the point. Don't waste my time.* What sort of person *chooses* to do interviews?

Contrarily, nothing can be more interesting than a question you've never been asked before, and when the process goes really well, you do end up with good friends for life, and I've been blessed that way. One thing I note with sadness is that I've never once "made it" with someone I've met during an interview. I don't think this indicates an absence of hotness among interviewers; rather, I think it emphasizes the utter unsexiness of interviews. Andy Warhol was on to something: People are boring. Machines are sexy. What shirt are you wearing? What did you eat for breakfast? A rule of thumb: After twenty minutes the questions get stupid. It really is the point after which you get asked what you ate for breakfast. The things that make one person different from another aren't all that great, and the twenty-first minute makes that all too apparent. These days, I've simply stopped giving a shit and say I mostly say exactly what's on my mind—which is maybe the way I should have been doing it all along. It makes for snarkier articles, but what's wrong with that? Being nice is boring. Being a bombast with Tourette's is far more interesting.

I doubt you're going to find many bombasts with Tourette's in Hans's vast catalogue of interviewees. Hans (who I always think of as HUO) is one of the few people who know what a true interview ought to accomplish, and he has an amazing knack for getting to the essence of a person. He's the press equivalent of laser eye surgery. With HUO you never get to the twenty-first minute, and with HUO you feel like you've had a conversation. He does it the old-fashioned way: in person, with a microphone, transcribing the results. Each person is a person, and each person is unique. This is a difficult feat to accomplish.

Hans, where were you twenty years ago? We could have done *one* interview together and I'd never have to do another interview again. I'd simply send people a photocopy of our interview and declare, "It doesn't get any better than this. Learn from the master."

Art by Instruction and the Prehistory of "do it"

Bruce Altshuler

> The aesthetic "attitude" is restless, searching,
> testing—it is less attitude than action: creation
> and re-creation.
> —Nelson Goodman[1]

"do it" unites two strategies employed at key moments
by the Conceptual avant-garde: the generation of works
using written instructions and the insertion of chance
into the realization of an artwork. Both of these tech-
niques have also surfaced throughout the history of the
avant-garde exhibition. The reason is not hard to find; for
not only have such exhibitions sought to instantiate the
ideas of the works contained within them, but advanced
exhibitions have come more and more to be approached
as artworks in their own right. Since the 1960s the con-
temporary curator has come to be seen as a kind of artist,
an auteur creating visual and conceptual experiences
related to those of the works exhibited. What we find
in the prehistory of "do it," then, is something like three
parallel narratives: developments tied to changing con-
ceptions of the artwork, the exhibition, and the curator.

In all of these areas, the critical progenitor is Marcel
Duchamp. While one can look to the studios of the Renais-
sance, say, for works created by individuals other than the
"artist of" attribution, the modern tactic of removing the
execution from the hand of the artist appears in 1919 when
Duchamp sent instructions from Argentina for his sister
Suzanne and her husband Jean Crotti to make his gift for
their April marriage. To create the oddly named wedding
present, *Unhappy Readymade*, the couple was told to hang
a geometry text on their balcony so that the wind could
"go through the book [and] choose its own problems."
Duchamp produced another instruction work in 1949,
when he asked Henri-Pierre Roché to make a second *50cc
air de Paris* after Walter Arensberg's original had been
broken, directing Roché to return to the Paris pharmacy
that Duchamp had visited in 1919 and have the druggist

1. Nelson Goodman, *Languages of Art: An Approach to a Theory of Symbols*
(Indianapolis, IN: Bobbs-Merrill, 1968), 242.

empty and reseal the same kind of glass ampule as was originally used.[2] Duchamp's use of chance had emerged earlier with the *Three Standard Stoppages* of 1913, created by dropping meter-long threads onto a canvas to generate new units of length that mock the idea of the standard meter. (That same year, Duchamp and his sisters Yvonne and Magdeleine wrote *Erratum Musical* by placing notes on a staff in the order in which they were randomly drawn from a bag.) And as a curator, in April 1917, Duchamp installed the "First Annual Exhibition of the Society of Independent Artists" by using, in effect, two chance procedures. For this New York show of 2,125 works, Duchamp directed that pieces be arranged alphabetically by artist's last name, determining by lot the letter *R* with which the installation began.[3]

While "do it" does not explicitly employ chance operations, its content is determined by a procedure whose results cannot be foreseen. So, as far as the curator and organizers are concerned, the process is functionally equivalent to chance. For viewers, on the other hand, the experience of the exhibition involves an awareness both of what is and of what might have been. Both these perspectives point to the work of John Cage, whose role in the genesis of art by instruction is central. In a series of classes given at the New School for Social Research between 1956 and 1960, Cage influenced a generation of artists who would develop the performance script into an art form and lay the ground for Happenings and Fluxus.[4] Having earlier embraced chance compositional procedures as a means of effacing his own likes and dislikes (and, as he put it, "Imitating nature in her manner of

2. Marcel Duchamp, quoted in Calvin Tomkins, *Marcel Duchamp: A Biography* (New York: Henry Holt, 1996), 212. On recreating *50cc air de Paris*, see 374.

3. On this exhibition, Duchamp's installation, and the critical response, see Francis Naumann, *New York Dada, 1915–23* (New York: Harry N. Abrams, 1994), 176–91.

4. For a detailed account of this class and its influence on the development of intermedia art forms, see Bruce Altshuler, "The Cage Class," in *FluxAttitudes*, ed. Cornelia Lauf and Susan Hapgood (Ghent: Imschoot Uitgevers, 1991), 17–23.

operation"), Cage encouraged students who already were
using chance in their work (such as George Brecht and
Jackson Mac Low) and prompted others (such as Allan
Kaprow, Dick Higgins, and Al Hansen) to do so. And his
classroom assignments led to instructions for events and
performances that yielded some of the most important
intermedia activity of the late 1950s and early 1960s.

Out of the Cage class came the kind of event cards
for which Fluxus would become well known, an evocative
form whose power is best appreciated in the 1959–66
works of George Brecht, published by the movement's
impresario George Maciunas in a box called *Water Yam*
(1963). While most Fluxus event cards are performance
scripts, *Water Yam* also includes instructions for the
creation of objects or tableaux—obscure directions whose
realization left almost everything to the realizer. In such
works as *Six Exhibits* ("ceiling, first wall, second wall, third
wall, fourth wall, floor") and *Egg* ("at least one egg"),
Brecht applied to objects and physical situations the
freedom of execution and openness to serendipity that
is the hallmark of a Fluxus performance. As we can see
in the pieces contributed by Kaprow and Alison Knowles
to "do it," alumni of the Cage class and their associates
continue to work in this spirit.

More than Brecht, however, Yoko Ono was the artist
during this period who most significantly focused on the
creation of objects from instructions. Although she never
studied with Cage, her husband at the time, composer
Toshi Ichiyanagi, was in the New School class, and Ono
was an active participant in the surrounding milieu.
At the time, Ono was best known for the series of events
that she and La Monte Young organized in her Chambers
Street loft, beginning in December 1960, but more inter-
esting for us is her July 1961 exhibition at Maciunas's
AG Gallery. Here, she displayed a group of works in
the process of realization, made from instructions to
be carried out by visitors. *Painting to Be Stepped On*, for
instance, called for viewers to walk on a canvas laid on
the gallery floor, and *Smoke Painting* was to be realized

by visitors burning the canvas with cigarettes and watching the smoke rise. Ono took the next logical step in her May 1962 exhibition at the Sogetsu Art Center in Tokyo, where, instead of objects created by instructions, she displayed only the instructions on sheets of white paper. In this show, ideas—exhibited as verbal directions—were marked as central. Yoko Ono released her paintings in the world, in the form of instructions, like the butterfly whose release in the concert hall constitutes La Monte Young's most poetic instruction piece. Calling for participation by others in an ongoing, free artistic process, Ono's instruction paintings were made available to a broader public in her book *Grapefruit*, first published in Japan in 1964.[5] An important aspect of such work is the tension between ideation and material realization; for while these pieces seem to be created by being imagined, as instructions for physical action they stake a further claim in the world.

Art in which ideas are primary and are presented via verbal description would reach its apogee within a decade in the broader Conceptual art movement. But the story of art by instruction first takes a turn into more rigorous sculptural practice with Minimalist fabrication. Of course, sculpture has a long history of works created by craftsmen casting or carving from the artist's maquettes and directions. And certain modern masters, such as Joan Miró, had extended this practice by having pieces fabricated according to oral or written instructions.[6] But the Minimalists

5. Yoko Ono has written that her primary interest in these works is "painting to construct in your head," tracing their origin to childhood experiences of hunger in wartime Japan, when she and her brother "exchanged menus in the air." Yoko Ono, "To the Wesleyan People (Who Attended the Meeting)—A Footnote to My Lecture of January 13th, 1966," in *Grapefruit: A Book of Instructions and Drawings by Yoko Ono* (New York: Simon & Schuster, 1970), n.p. Ono's piece for "do it," instructing visitors to write their wishes on pieces of paper and tie them to a tree, recalls her Japanese childhood as well, when she would visit a temple and tie her wishes to a tree along with those of other supplicants.

6. According to Georges Hugnet, Miró sent instructions to a carpenter to make such works as *Relief Construction* (1930), now at the Museum of Modern Art, New York. Georges Hugnet, "Joan Miró, ou L'enfance de l'art," *Cahiers d'Art* 6, nos. 7–8 (1931): 335. For this reference I thank Anne Umland at the Museum of Modern Art, New York.

were motivated very differently than earlier sculptors, for their use of industrial fabrication was a reaction—as was the work in the Cage and Fluxus circles—to the aesthetic ideology of Abstract Expressionism.[7] When Donald Judd, Robert Morris, or Dan Flavin had sculptures fabricated from construction drawings, they were striking a blow against that movement's focus on the artist's hand and the central position held by the subjectivity of the maker.

In Minimalist practice, as in "do it," instructions and anonymous fabrication impose a distance between the artist and the realized artwork. The role of the artist is thus transformed from maker to conceiver. This connection between Minimalism and Conceptualism was made clear by Sol LeWitt in his important "Paragraphs on Conceptual Art," published in June 1967 in *Artforum*. Here, LeWitt valorized ideas rather than their physical instantiations, and he accepted unrealized concepts as works in their own right. And as concepts became the focus, their linguistic expression was admitted as an artistic form. Artworks could be embodied in statements, and a collection of statements could constitute an exhibition.

The move from conceptual work to conceptual exhibition was made by dealer/publisher/organizer Seth Siegelaub in his exhibition "Douglas Huebler: November, 1968." Lacking an exhibition space, Siegelaub presented Huebler's show in the form of a catalogue alone. Here Huebler's pieces—space-time constructions imperceptible at any one time or place—appeared as verbal descriptions, maps, and other documentation. The next month Siegelaub published *Lawrence Weiner: Statements*, not explicitly introduced as an exhibition but clearly functioning that way. Weiner's works were presented in written form—"Two minutes of spray paint directly upon the floor from a standard aerosol spray can"—and they each specified a material process that could be carried

7. Two artists associated with Minimalism, Robert Morris and Walter De Maria, first made such sculptural objects as part of performances related to early Fluxus. See Bruce Altshuler, *The Avant-Garde in Exhibition: New Art in the Twentieth Century* (New York: Harry N. Abrams, 1994), 223, 233.

114

out in the world. (Whether his instructions ever were carried out, whether the work actually was physically realized, was a matter of indifference to Weiner, who left that decision to the "receiver.") In January 1969, Siegelaub mounted his most famous exhibition in an unused office on East 52nd Street in New York, yet even here the catalogue was fundamental. For while the exhibition known as "The January Show" displayed in physical space pieces by Robert Barry, Douglas Huebler, Joseph Kosuth, and Lawrence Weiner, Siegelaub insisted that the catalogue was primary: "The exhibition consists of (the ideas communicated in) the catalogue; the physical presence (or the work) is supplementary to the catalogue."[8]

By 1969 the international art world was exploding with art by instruction, much of it created for radical exhibitions mounted in Europe and North America. The proliferation of the form was driven by two factors: the nature of much new art allowed for it to be made on the basis of artists' directions, and the great demand by curators of large shows for pieces from artists unable to travel to distant venues. I cite a few examples from two of the most important exhibitions of that heady year: Lucy Lippard's "557,089" and "955,000" (two versions of a show named for the populations of the cities in which it was mounted—Seattle, Washington; and Vancouver, British Columbia), and Harald Szeemann's "When Attitudes Become Form: Works-Processes-Concepts-Situations-Information (Live in Your Head)" at Kunsthalle Bern.[9]

8. For an account of these works and exhibitions, see Altshuler, 236–43.

9. "When Attitudes Become Form" was mounted at the Kunsthalle Bern, Switzerland, March–April 1969, and later traveled to the Museum Haus Lange in Krefeld, Germany, and London's Institute of Contemporary Art. Instructions for works in both of these exhibitions are included in their catalogues, with the catalogue for "557,087" consisting of a set of four-by-six-inch cards that detail each piece. See also Lucy Lippard, *Six Years: The Dematerialization of the Art Object from 1966 to 1972* (Berkeley: University of California Press, 1997), 110–12; and Altshuler, *Avant-Garde in Exhibition*, 243–55. While instructions for works in such exhibitions generally were provided to the curator in written form, an important exception is Jan van der Marck's 1969 show at the Museum of Contemporary Art in Chicago, "Art by Telephone," for which instructions could be communicated only by telephone (see note 14).

For "557,089," Robert Smithson sent instructions for a work consisting of four hundred photographs to be taken of deserted Seattle horizons with a Kodak Instamatic camera; and for "955,000," Jan Dibbets sent directions for recording a tape of the sounds of a car trip of up to thirty miles, with the driver verbally counting out the miles driven, to be played continuously in the exhibition under a map of the route taken. For "When Attitudes Become Form," Robert Morris instructed the Kunsthalle staff to collect as many different kinds of combustible materials as were available in Bern and, beginning with one kind, add different sorts of materials at units of time to be determined by dividing the length of the exhibition by the number of materials. On the last day of the exhibition, with all the materials having been "placed freely in the space," they were removed and burned outside the museum. And for both Lippard's and Szeemann's exhibitions, Sol LeWitt sent detailed instructions for the creation of wall drawings. The works-by-instruction created by American and European artists during this exciting period, and the curatorial activity that often elicited these pieces, constitute the critical precedent for "do it."[10]

Like many of the avant-garde exhibitions of this century, "do it" itself exemplifies the characteristics of the art that it contains. Just as important Surrealist exhibitions were themselves Surreal works in the form of constructed environments—witness Duchamp's installation of the 1938 "International Exposition of Surrealism," or Frederick Kiesler's design for Peggy Guggenheim's "Art

10. There are many subsequent instruction works, of course, and later exhibitions that embrace this form. Two noteworthy cases are Nina Felshin's "The Presence of Absence: New Installations," organized in 1988 by Independent Curators Incorporated and containing instruction pieces by thirteen artists, and John Cage's "Rolywholyover: A Circus," organized by the Museum of Contemporary Art, Los Angeles, in 1993. "The Presence of Absence" traveled to eleven venues in 1989–90, and—like "do it"—was realized simultaneously in different locations. "Rolywholyover A Circus," which traveled internationally, included a huge number of non-instruction works, but the composition and installation of the exhibition constantly changed according to a Cage-created set of instructions employing chance operations.

116

of this Century" (1942) and the Hugo Gallery's exhibition "Bloodflames" (1947)—"do it" is a work of the same kind as its components.[11] "do it" is a do-it, a work to be realized from instructions, and, as with other pieces of art by instruction, it can be done simultaneously in more than one place. The exhibition comes with rules that must be followed by the institutions mounting the show: the requirement that the works be destroyed after the exhibition, for example. But like all art by instruction, "do it" is essentially open, allowing for a range of realizations according to the interpretations, choices, and constraints of those who follow the directions. Like the works comprising it, "do it" is a multiple of potentially unlimited variety and number.

These features of instruction works raise philosophical questions regarding the identity of such pieces, and therefore about the nature of this sort of artwork. The questions are of two kinds. First: What exactly is the artwork here—the idea as stated in a set of directions, the actual words and instruction diagrams themselves, or the set of all realizations?[12]

Wittgensteinian worries about what it is to follow a rule—a consequence of any rule or instruction being interpretable in so many different ways—prompt a second set of questions: How closely must one follow the instructions of "do it," or of the works comprising the show, to count as realizing this exhibition, or that particular work? How important in this regard are the curator's or the artist's intentions, and what other factors are relevant? It would be foolhardy to try to settle these matters here, but the prehistory of "do it" suggests answers that emphasize openness of interpretation and that move in the direction of freedom.

Freedom and openness to novel exhibition forms characterize "do it" and Obrist's curatorial work in general. Very much in the spirit if his avant-garde precursors—

11. For these exhibitions, see Altshuler, *Avant-Garde in Exhibition*, chap. 7.
12. This last suggestion follows Nelson Goodman's rich analysis of performance works in Goodman, *Languages of Art*, 99–123, 177–221.

beginning with Jules Lévy, whose 1882 "Arts incohérents" exhibition in his Paris apartment looks forward to Obrist's 1991 and 1993 exhibitions in his Swiss kitchen and Paris hotel room[13]—Obrist has sought to show art in new ways and in unexpected places. While he departs from his predecessors of the 1960s and 1970s by wholeheartedly accepting the museum as a legitimate venue, reasoning from the inevitable institutionalization of successful anti-institutional forms, Obrist has sought space for freedom within the museum by such artistic interventions as his "Migrateurs" series at the Musée d'art moderne de la ville de Paris. "do it" also creates such a space within the museum.

This lack of being burdened by historical predecessors also characterizes the work of the younger artists in the show, such as Jason Rhoades and Rirkrit Tiravanija, who are at home in the establishment settings that once made their older colleagues so uncomfortable. The spirit of "do it" is thus very much of our time, enjoying in postmodern pastiche both nostalgia for the 1960s and accommodation with the institution. This is clear from the exhibition title, which prompts two very different associations: Jerry Rubin's battle cry from 1968—the year of Obrist's birth— and the familiar advertising slogan for Nike athletic shoes. "do it" is a delicate high-wire act, balancing subversion with curatorial and artistic renewal. And with these instructions in hand, it is an easy act to follow.

Postscript (2012)

When writing about "do it" in 1997, my focus was the way in which this exhibition perpetuates the Conceptualist tradition of the instruction work. This lineage is constituted by a fascinating set of historical precedents that applies both to the works that it contains and to the structure of the

13. For Jules Lévy's apartment exhibition, see Dennis Phillip Cate, "The Spirit of Montmartre," in *The Spirit of Montmartre: Cabarets, Humor, and the Avantgarde, 1875–1905*, ed. Dennis Phillip Cate and Mary Shaw (New Brunswick, NJ: Jane Vorhees Zimmerli Art Museum, 1996), 1.

exhibition itself. Like Fluxus performance scripts and many central works of Conceptual art, the pieces in "do it" appear initially as concepts for artworks presented through verbal instructions. As an exhibition, "do it" extends the example of shows created by following artists' instructions, such as Jan van der Marck's planned "Art by Telephone" and Lucy Lippard's "numbers exhibitions" in Seattle and Vancouver.[14] But fifteen years later, "do it" very clearly can be seen as an important part of another lineage, that of an intense period of curatorial innovation that began in the mid-1980s and has extended into the first decade of the new century. In particular, "do it" needs to be considered within the context of Hans Ulrich Obrist's ongoing curatorial project.

Obrist is fond of viewing his curatorial work through the metaphor of the laboratory, a place of collaborative experimentation and research where a particular result is hoped for, but unanticipated consequences often lead in new and startling directions.[15] In fact, in 1999 he and Barbara Vanderlinden mounted a multi-site exhibition project in Antwerp entitled "Laboratorium," assembling scientists and artists in situations of joint exploration,

14. "Art by Telephone" was never mounted at the Museum of Contemporary Art Chicago in 1968, as planned: a show in the galleries constructed from instructions given over the phone to van der Marck by thirty-six European and American artists. But the next year the museum produced a 44-minute record with the artists' telephoned instructions: an object—like the catalogue exhibitions of Seth Siegelaub—that itself effectively constitutes an exhibition. On this show, see "Art by Telephone," UbuWeb, accessed August 5, 2012, http://www.ubu.com/sound/art _by_telephone.html. For Lippard's exhibitions, see *From Conceptualism to Feminism: Lucy Lippard's Numbers Shows, 1969–1974*, ed. Cornelia Butler (London: Afterall Books, 2012); and *Materializing "Six Years": Lucy R. Lippard and the Emergence of Conceptual Art*, ed. Vincent Bonin and Catherine Morris (Cambridge, MA: MIT Press, 2012).

15. Obrist's reference point here is the notion of the museum as laboratory, associated with pioneering museum director Alexander Dorner's work in the 1920s and 1930s at the Landesmuseum in Hanover, Germany. On Dorner's innovative way of viewing the museum, see Joan Ockman, "The Road Not Taken: Alexander Dorner's Way beyond Art," in *Autonomy and Ideology: Positioning an Avant-Garde in America*, ed. R. E. Somol (New York: Monacelli Press, 1997); and Samuel Cauman, *The Living Museum: Experiences of an Art Historian and Museum Director—Alexander Dorner* (New York: New York University Press, 1958).

and investigating an expanded notion of the laboratory.[16] As in much of his curatorial work, and in addition to fostering collaboration among participants, Obrist developed this project with another curator in a mode that echoes the collective nature of scientific experiment and laboratory research. Collaboration is also built into the structure of "do it," with those who realize the pieces working with one another and with the show's organizers as well as, implicitly, with the artists. Additionally, each instantiation of "do it" contains a great deal that is unforeseen; the open-ended nature of instruction works allows for much spontaneity and variability of outcome.

The unpredictable and extemporaneous began to enter contemporary art exhibitions in a significant way in the late 1960s and 1970s, when artists often were asked to display pieces that the curator had not already seen. This stemmed largely from the process-based, conceptual, or performative nature of much work of the time, along with the growing use of artist-submitted proposals for the curating of exhibitions. The reliance on artist commissions during the 1990s and into the 2000s, most notably in the expanding realm of international biennials, took this development to a new level. It built unpredictability and experimentation into the very texture of large exhibitions, especially in shows that emphasized interaction with locality through works created for nonstandard sites. Variable and unexpected developments also were characteristic of exhibitions associated with "relational" art making.[17]

16. Hans Ulrich Obrist and Barbara Vanderlinden, *Laboratorium* (Antwerp: DuMont, 2001). "Laboratorium" continued an avant-garde practice of collaboration among artists and scientists seen earlier in "9 Evenings: Theatre and Engineering" in New York in October 1966, initiated by Experiments in Art and Technology (E.A.T.), beginning in 1967, and in the Art and Technology Program of the Los Angeles County Museum of Art (1967–71).

17. This notion of the relational received its classic statement in Nicolas Bourriaud, *Relational Aesthetics* (Dijon: Les presses du réel, 2002). For an account of many exhibitions associated with relational art making, see Nancy Spector, ed., *theanyspacewhatever* (New York: Guggenheim Museum, 2008).

"do it" was the first of Obrist's exhibitions to employ a particular structure to facilitate collaborative experimentation with open-ended results: that of an exhibition that changes over time across multiple venues. Paradigmatic here is "Cities on the Move," cocurated with Hou Hanru, which from 1997 to 1998 traveled to seven locations as a kind of roving research lab investigating the hypergrowth of Asian cities through projects by artists, architects, and urbanists. The list of participants was different at each venue, as were the specialist advisors, and new projects often were generated by what had occurred at a previous site. Another example of an exhibition conceived to change as it moved was "Utopia Station," curated by Obrist, Molly Nesbit, and Rirkrit Tiravanija. Most ambitiously realized at the 2003 Venice Biennale, it was developed over the next year and a half in very different ways at the Haus der Kunst in Munich, and the World Social Forum in Porto Alegre, Brazil.[18]

Obrist has called "Cities on the Move" and "Utopia Station" "evolutional exhibitions."[19] But his reference to evolution should not be interpreted in terms of progress toward a better example. Rather, these shows are constituted by alternative developments around a similar set of concerns, with later iterations responding both to earlier versions and to new conditions. In explicating this idea, Obrist has employed analogies from a range of fields, including biology (metabolism), information theory (feedback loop), learning theory (dynamic learning system), and geology (sedimentation). The process by which "do it" has grown and diversified readily falls under these concepts. In each of these exhibitions, the entire series

18. The model of an exhibition changing across venues was used again in "Indian Highway," curated by Obrist, Julia Peyton-Jones, and Gunnar B. Kvaran, which was shown in London, Oslo, Lyon, Rome, and Beijing from 2008 to 2012.

19. Hans Ulrich Obrist, "Evolutional Exhibitions," 1st Biennale of Ceramics in Contemporary Art (2001), http://www.attesedizioni.org /eng/biennali/prima_biennale/obrist.html. For further discussion of such exhibitions, see Hans Ulrich Obrist, interview with Paul O'Neill, accessed August 10, 2012, http://www.contemporarymagazines.com/profile77_6 .htm (site discontinued).

of instantiations constitutes a single research enterprise engaged with a fluid set of ideas and issues.

The notion of an exhibition as an evolving series of diverse iterations also exemplifies a more general form of curatorial innovation, one that alters the spatial and/or temporal parameters of the traditional exhibition. When Seth Siegelaub organized thirty-one artists to each create a work on one day of a given month ("March 1–31, 1969") or had eleven artists each make a piece to be shown simultaneously in eleven different locations worldwide ("July, August, September 1969"), he was playing with the spatiotemporal variables of the exhibition form. Wim Beeren altered the typical locational model of the exhibition in "Sonsbeek '71: Beyond Lawn and Order" (1971), with works and projects spread throughout the Netherlands, as did Jan Hoet with "Chambres d'amis" (1986), by dispersing the show to private residences around Ghent, Belgium. In Chicago, Mary Jane Jacob expanded the normal exhibition time frame in "Culture in Action" (1993), in which the projects extended over the course of five months, and Maria Lind did the same with her yearlong retrospective of the work of Christine Borland at the Kunstverein München (2002–3). The structure conceived by Okwui Enwezor for documenta 11 (2002), which consisted of five successive "platforms" held around the world over a period of eighteen months, presents another radical break with the space-time constraints of the standard exhibition.[20]

Hans Ulrich Obrist began to develop "do it" at the outset of his curatorial career, as he was becoming increasingly interested in theoretical issues around the exhibiting of art. "do it" provided an ideal vehicle for the exercise of this interest, pointing toward important

20. All of these examples also involve other kinds of innovation, with Siegelaub presenting the catalogue as a primary exhibitionary site, Beeren knitting new forms of communication into the structure of the show (including a dedicated radio station), Hoet moving a public exhibition into private domestic spaces, Jacob employing community projects as works of sculpture, Lind creating a retrospective by showing a single work each month, and Enwezor developing a thoroughgoing discursive exhibition model.

historical precedents in art and exhibition making and providing a new model of what an exhibition could be. The ongoing development of "do it" would coincide with the growth of his curatorial practice and exhibitionary thinking, connecting both with particular concepts, such as that of an evolving exhibition, and with a general perspective that emphasizes the creative possibilities of the exhibition as an experimental form. As it encompasses more and more artists, participants, and sites, "do it" epitomizes the expansive spirit of an important period of innovative curatorial activity.

Curators: Hans Ulrich Obrist

For me, Hans Ulrich Obrist is *the* curator who allowed me to change my life.

In 2003, when he decided to create "Utopia Station" with Rirkrit Tiravanija and Molly Nesbit at the Venice Biennale, he invited people from outside the art-world circle, including myself, Édouard Glissant, and others. It came at the right time: I was hoping so much to cross the border between cinema and visual art.

We had met in 2002 when he came to have a long conversation with me as filmmaker for his huge book of interviews.

It seems that for years Hans Ulrich, also known as HUO, wanted to record as many memories and words of the so-called cultural world, and mostly the old people ... before they died.

We spoke a lot and I learned about him: that he had held his first exhibition as a curator in his kitchen in Zurich when he was eighteen, that for years he slept only two or three hours per night, which allowed him to read all kinds of books including poetry or philosophy.

On the subject of poetry, HUO curated the "Poetry Marathon" at the Serpentine Gallery in 2009. I read Rilke in German, Jim Morrison in English, and, in French, the beautiful words of Louise Labé and Mallarmé. He introduced each reader.

All these are just drops in the river of his imagination and work. He has shared many projects with others and he started to do so early on. With Christian Boltanski he created this free, thin, large-format magazine, *Point d'ironie*, for agnès b. I was invited to do one, so I sent a huge postman mural. Mailmen are go-betweens. So is Hans Ulrich. He connects people, he pushes ideas and projects and then allows artists to be free. He is a nonstop creator-curator.

Sometimes his ideas make me smile. At Art Basel in 2013, he created a panel group to discuss "The Artist as Farmer." Some of us spoke behind a stack of organic vegetables and fruits.

It brings me back to the first Venice Biennale, where I showed a triptych of heart-shaped potatoes with seven

hundred kilos of real potatoes on the ground, *Patatutopia*.
 Next time he comes to Paris, I'll feed him with a puree of hand-smashed heart-shaped potatoes.

Coffee

Andrew Durbin

Coffee

I met Hans Ulrich on a warm January afternoon in Zurich
several years ago, on my first trip to Europe. He was the
host of a poetry reading at the LUMA Foundation, where
he introduced me to a mostly European audience of quiet
gallerygoers. I got up, thanked him, read a poem I'd
written about motorcycles, left to enjoy the sauna by the
lake, then had sausages on a dock under flat, slate-gray
clouds that lazily spilled down from the distant Alps
toward the city. Is that the order of the day? With Hans
Ulrich, particulars—and peculiars—jumble, rearrange
into better stories, one he writes into vivid language,
the language of *being there*. For Hans Ulrich, one is always
there, and that's the point: To get into the face of things.
To see them up close, analyze the imperfections of some-
thing or face which make up the jagged differences that
separate certain things and faces from other things and
faces. Mostly, he likes to know what isn't Hans Ulrich.
Anyway, he'd brought me over to Europe, so I owe him
that, to begin with, though I also owe him for introducing
me that day to the poet Etel Adnan, who had long been
a hero of mine. I'd admired her work from afar and I had
never expected to meet her, Etel being at a distant, almost
magical remove from the life I lived in New York City.
Etel and I had potato salad together on a park bench in
a gallery. We talked about San Francisco, which is still
the prettiest city in the United States, and—perhaps she
agreed with me on this point—that it's beautiful but
changing for the worse and so, at that moment, was even
more beautiful because it was leaving us to become
something else—a tech thing that would have no time
for poetry things. She told me, if I remember correctly,
that she missed it, the view of Mount Tamalpais, which
she frequently paints. Only recently I'd gone on a hike up
that mountain, or on a mountain near that mountain,
through a long baby redwood forest that sputtered out
near a cliff face overlooking the Pacific, where the United
States had installed—and abandoned—anti-aircraft
bunkers that had long been overgrown with weeds and
graffiti. Did I tell Etel about this? That at the end of my

130

hike I rammed into history? Or did it happen later, after
I met her. I can't remember. Again, what's order when
Hans Ulrich's around. The story is better if I told her
about that hike. In any case, Hans Ulrich stood nearby
beaming or indifferent, the two always seemingly interre-
lated with him because he knows the two are equal parts,
essential to living among so many interesting people and
places. It all matters, and when everything matters you
can only stand it if you make a few choices about your
attention and what it spans. The reading ended, the
weekend ended, I went back to New York, to my office job,
which was so dull I quit because now I'd met Etel Adnan
(really, I did quit because I met Etel Adnan), friend of
Hans Ulrich Obrist, and I wanted to be a poet—or, more
accurately, I wanted to be a writer like her, someone who
refused the distinction between poetry and the things
that aren't poetry, like art and fiction—and that can't be
done in an office job like the one I had. At least I couldn't
do it. I know so many who have, but I'm not them, as
Hans Ulrich must have known, since he's the one who
opened that door and said, "Get out," certain that I had
to leave—and would. I did. That summer I went to Lon-
don for the first time, where Hans Ulrich lives and works
at the Serpentine Galleries, among the swans that only
the queen is permitted to eat. I had lunch with the poets
Harry Burke and Sophie Collins, who'd just written a
poem about Hans Ulrich jogging through Kensington
Gardens. In the poem, he detours down a slope to inter-
rupt a downy arrangement of sleeping swans in order to
wake them up. The poem had to do with a rumor Sophie
had heard that HUO never sleeps and doesn't believe,
as a point of pride, in sleep. We must stay up, and there-
fore keep going. After lunch, Harry and I went to the
Serpentine to visit Hans Ulrich in his office. The first
thing he did was give me a great, hulking catalogue of
Etel's work, which I then lugged all day and all night
(from the Serpentine, to dinner, to a party, to a bar, to a
house at 5 a.m., to a bus to Lewisham, where Harry lived,
to Harry's apartment, to the couch where I finally passed

out well into morning). Then Hans Ulrich left us in his
office for a quick meeting, assuring us he'd back shortly.
In the meantime, he sent in a French press on a silver
tray with porcelain cups and cookies, though, of course,
he called them *biscuits*. Such is England. I pushed down
on the press's silver handle, a little too fast, and so the
thing exploded, coffee everywhere: all over Harry, me,
Hans Ulrich's notebooks, papers, and his computer.
Gah, I flipped; I was so embarrassed. I'd just destroyed
his computer! Ruined his notebook! Soaked Harry!
All these people came rushing in, including Hans
Ulrich. What happened, someone said. I said, I fucked
up. Harry said, No kidding. Then we cleaned it up,
Hans Ulrich laughed it off, the computer was fine, the
notebook ruined. But now it has your touch, he said,
holding it up for us to see. The touch of coffee. That's
when I considered him a friend.

Zyzio

Sophie Collins

Hans Ulrich Obrist throws bread to the swans in the Royal Park of Kensington Gardens in central London. It's early morning. The bread isn't stale. The swans are not white; they are gray-brown. One of the swans is sitting a good distance away from the main body of the group. It's darker or dirtier than the rest and shows no interest in the bread. Its eyes are closed, and its neck is bent at an angle that allows it to rest its head on its back. Hans Ulrich Obrist approaches the swan.

As he gets close, the swan opens its eyes and lifts its head. Its neck sways, and it lets out a rasp from its gray beak. Hans Ulrich Obrist takes a slice of bread from the bag and tears out a small piece with no crusts, tossing it directly in front of the swan. The swan ignores the bread, but the rest of the group swarms over, trampling the crustless piece and nipping at the bag in Hans Ulrich Obrist's hands. The swan looks resigned. It tries to reposition its head on its back but misses and lays it on the tarmac instead. It closes its eyes. Hans Ulrich Obrist turns and leaves the pond area.

That evening, he is unable to sleep, and the following morning he wakes uncharacteristically late, at 10:47 a.m., to a series of emails and one missed call from the team at the gallery. He postpones responding and gets dressed. He walks to the park and alerts the warden to the sick swan. He feels no sense of immediate relief but finds that he is once again able to focus on other things. When he visits the pond area again two days later, the sick swan is gone, and he senses that it has been euthanised. The crustless piece of bread is still partially visible, specked with dirt and embedded in the tarmac. It doesn't at all resemble the unmistakable image of Mary Immaculate, mother of Jesus. A light snow does not begin to fall.

The Archaeology of Things to Come

Daniel Birnbaum

A Brief History of Curating is a book about Hans Ulrich Obrist's precursors, his grandparents. But his professional parents, Suzanne Pagé and Kasper König, his most influential teachers in the world of exhibition making, are not present, and would probably require an additional volume. So let me begin by citing from a conversation I had with Pagé about curating. The interview, published in *Artforum,* is the result of an encounter that Hans Ulrich facilitated in 1998, during a period in which he was visiting me regularly in Stockholm while preparing "Nuit Blanche," a large Scandinavian exhibition.

Daniel Birnbaum: It seems to me that although you're the director of a powerful institution, you've never tended to take center stage yourself. You present a rather low-key version of the curator's role.

Suzanne Pagé: Yes and no. I don't like to put myself into the spotlight, but I like to illuminate the backstage. What I suggest is actually very demanding. It takes an effort not to emphasize your own subjectivity, and to let the art itself be at the center. The real power, the only one worth fighting for, is the power of art itself. Artists should be given maximum freedom to make their visions clear to others, and to exceed the limits. That is my role, my real power. The curator helps to make that happen. And the best way for me to do so is to be open and lucid enough to accept the new worlds that artists reveal in their most radical dimension.

Birnbaum: But you choose who is going to show in the first place. You can't deny that this involves great power.

Pagé: The curator should be like a dervish who circles around the artworks. There has to be complete certainty on the part of the dancer for it all to begin, but once the dance has started it has noth-

136

ing to do with power or control. To a certain degree it is a question of learning to be vulnerable, of remaining open to the vision of the artist. I also like the idea of the curator or critic as a supplicant. It's about forgetting everything you think that you know, and even allowing yourself to get lost.

Birnbaum: This reminds me of what Walter Benjamin writes in *Berlin Childhood around 1900*, where he says that it takes a lot of exercise if you want to learn how to really get lost in a city.

Pagé: Yes, what I'm after is a form of concentration that suddenly turns into its opposite, being available for a true alternative adventure.

About a decade later, Hans Ulrich sent me an interview with Kasper König, perhaps his most important mentor, where similar thoughts about the fundamental invisibility of the curator are expressed: "Yes, keeping things simple is always my motto: here on the one hand there are the works of art, quite traditionally, not the artists but the products of artists, and on the other the public, and we're in-between. And if we do our work well, we disappear behind it."

It was in 1967 that John Barth published his controversial essay "The Literature of Exhaustion," in which he proposed that the conventional modes of literary representation associated with the novel had been "used up," and that the novel was worn out as a literary format. After the death of the novel one can either be naive and continue as if nothing has happened (as thousands of writers do), or one can make the very end of the genre productive: from Jorge Luis Borges to Italo Calvino one finds fantastic versions of a such "literature after literature" in which the endgame is turned into a new kind of writing. A case in point: Calvino's brilliant 1979 meta-novel *If on a Winter's Night a Traveler*, which accommodates so many incompatible books. Perhaps it is in the same

way that painting is dead and yet kept alive by Gerhard
Richter, who paints in all styles, giving priority to none.
At least this is the position that critic Benjamin Buchloh
wanted the artist to accept in a legendary interview.[1]
In a grandiose way, Richter would thus demonstrate
the end of his discipline.

In a comparable way, it would seem that the biennial
has reached its unavoidable end. But reaching this end
is perhaps necessary if one is looking for a new start. Hans
Ulrich Obrist knows this and therefore, in collaboration
with Stéphanie Moisdon, he staged the Biennale de Lyon,
which opened in September 2007, as a kind of meta-
literary game. In the spirit of Oulipo (an experimental
group of poets and mathematicians), the whole event was
reduced to a list of manuals, the curator was nothing but
an algorithm. Perhaps another version of an end was
marked by Francesco Bonami's installment of the Venice
Biennale in 2003—at least that is how Obrist and I thought
about it when preparing our sections. The show contained
a multiplicity of shows: the most extreme, dense, and
impressive exhibition of contemporary Asian art ("Z.O.U.–
Zone of Urgency," curated by Hou Hanru), sections organ-
ized by artists (Gabriel Orozco and Rirkrit Tiravanija),
a kind of laboratory in the garden ("Utopia Station,"
an Obrist, Tiravanija, Molly Nesbit collaboration), and
numerous other incompatible exhibitions displaying their
own logic. It was a heterogeneous event; in a way it was
the biennial to put an end to the biennial as an experimen-
tal form. It tried to exhaust all possibilities at once, and
pushed the plurality as far as possible. Many people didn't
like it much, but I have a sense that almost everything
coming after this endeavor will look conservative.

The end of the biennial does not mean that no more
biennials will be staged (just as the "death of the novel"
never meant the disappearance of actual books from
the stores). On the contrary, there are more biennials

1. Benjamin H. D. Buchloh, "Interview with Gerhard Richter,"
in *Gerhard Richter: Forty Years of Painting* (New York: Museum of Modern
Art, 2002).

than ever. But as a form for experimentation and innova-
tions it seems that it has reached a stage where it must
reinvent itself. The idea that forms of artistic expression
can exhaust themselves is nothing new. For instance, in
the mid-1920s the very young Erwin Panofsky made a
similar claim in *Perspective as Symbolic Form* (1927): "When
work on certain artistic problems has advanced so far
that further work in the same direction, proceeding from
the same premises, appears unlikely to bear fruit, the
result is often a great recoil, or perhaps better, a reversal
of direction." Such shifts, says Panofsky, are always
associated with a transfer of artistic leadership to a new
country or to a new discipline.

But the biennial is not an art form, so how does this
comparison with painting and literature function, some
of you may wonder. I am not so sure. With figures such
as Pontus Hultén and Harald Szeemann, who both recently
passed away, the role of the curator took on new qualities.
Szeemann sought, he said, to create shows that were
"poems in space." And in the wake of his move away from
all traditional museological attempts to classify and
order cultural material, the figure of the curator could
no longer be seen as a blend of bureaucrat and cultural
impresario. Instead, he emerged as a kind of artist him-
self or, as some would say—perhaps with some skepticism
toward Szeemann's genuine belief that art exhibitions
were spiritual undertakings with the power to conjure
alternative ways of organizing society—a meta-artist,
utopian thinker, or even shaman. A comparison with
Hultén, the founding director of the Centre Pompidou,
offers a way to think through a crucial distinction—
one having to do with institutional models and the very
conception of curating. It could perhaps be said that
Szeemann and Hultén defined opposite ends of the
spectrum, and in so doing vastly expanded the spectrum
itself. Szeemann chose not to direct a museum and
instead invented a new role: that of the independent
Ausstellungsmacher, who carries his own museum of
obsessions in his head. Hultén, on the other hand, and

more than anyone else, tested the limits of the contemporary art museum from within and tried to turn the whole institution into a radically multidisciplinary laboratory and production site. Now Hultén and Szeemann have both left us, and we have to sort out a global environment that they were instrumental in shaping. The successful museum has become a corporation, the biennial is in crisis. What is waiting around the corner? Of course art fairs that pretend that they are exhibitions, and a brand new park in Abu Dhabi where, perhaps, in a few years, there will be a supersized biennial on steroids. In recent times we have witnessed a marginalization of all functions in the art world, which suggests the possibility of something significant taking place outside of the market. The critic was marginalized by the curator who, in turn, was pushed aside by the advisor, the manager and—most importantly—the collector and the dealer. There can no longer be any doubt: for many the biennial has been eclipsed by the art fair.

But no doubt there will be a new start. Somewhere in the near future, it will happen, because things don't just end like this. When new cultural formations appear they tend to use fragments from already obsolete forms. Panofsky pointed this out: the future is constructed out of elements from the past—nothing appears ex nihilo. The future of exhibition making will deploy devices we once knew but had forgotten about. This book is a unique toolbox, and Hans Ulrich Obrist is not simply an archaeologist, he is also a guide into artistic landscapes that are yet to emerge.

Taking Art Seriously

Boris Groys

To write about Hans Ulrich Obrist is an easy and difficult
task at the same time. Obrist is a protean figure—and he
seems to be present everywhere in the art world. So to
write about Obrist is almost the same as to write about
the art world as a whole. It is easy to say something true
about the art world but the totality of it remains elusive.
However, one can find useful advice on how to write about
world in its totality; I mean the famous sentence from
Wittgenstein's *Tractatus Logico-Philosophicus* (1922):
"The world of the happy is quite another than that of the
unhappy." Indeed, when I think about the different actors
operating inside the art world I cannot escape the impres-
sion that they experience this world in very different ways.
Some of them enjoy it as an interesting spectacle, some
of them carry it as a burden. Of course, one can diversify
these descriptions—and add more of them. But let me say
what impression I have of Obrist's attitude toward the art
world. It seems to me that he takes it very seriously.

Now, what does it mean to take art seriously? At least
from my perspective it means to be able to see the artist
behind the artwork. We are living in the middle of infor-
mation networks that permanently supply us with images.
The origin of these images remains unclear—the goal of
their travel remains likewise obscure. So it is difficult to
resist the seduction to see the art world as the vast mass
of anonymous art products—as anonymous as the products
one sees on the shelves in a supermarket. Of course, there
are always names of the artists ascribed to the individual
images, but there are also brands ascribed to the products
in the supermarket. Both types of names seem to be mere
conventional signs related to the price of an individual
product. That is why there are so many art consumers
and even critics who would like to abolish these traces
of the origin and make art totally anonymous.

This kind of attitude toward art is completely legiti-
mate, but it is not serious. It is not serious because it
overlooks the fact that for the artists to make their art is
a serious matter. Art making defines the life of the artists
in a much more profound and decisive way than any other

profession defines the life of the people who practice it.
Especially in our time, every art project is at the same time
a life project. To make a certain kind of art means to live
a certain kind of life. Maybe it was different in earlier
times when art making was well-defined by the tradition.
But today nobody knows what it means to make art—just
as one does not know what it means to live. As an effect
of this fundamental uncertainty, art functions today as
a proposition of a certain lifestyle, political attitude,
social practice.

Now, Obrist is informed about the international art
scene better than maybe anyone else. But I was always
impressed by his curiosity toward the reasons that an
individual artist had to produce this or that artwork, to
make this or that art gesture. What is the vision behind
it? What is the life project that has manifested itself in
this way? Obrist is always trying to understand the
motives and projects of artists. And he always asks him-
self and others, Would it be possible to carry an artistic
project even further than the artist himself or herself was
willing to do it? What would happen if an artwork would
be seen not as an object in the world but as a model of a
different world—a different type of sensibility, a different
way of communication? And maybe most importantly:
Would it be possible to realize, by means of a curatorial
practice, a project suggested by an artist—and thus
maybe come to a different but also interesting result?

A friend of mine once said that there are two kinds
of people: There are those of us who believe others do what
we do not because they are different. But there are also
those of us who believe that others are able to realize the
possibilities that we ourselves have missed out on. It is this
second attitude that I would call a serious attitude. And
I always feel this serious attitude when I've had an occa-
sion to speak with Obrist—but also when I read his mem-
oirs and interviews. He describes all his encounters with
art and curatorial practice as leading to the same ques-
tion: Is it desirable and possible for him to do something
similar—or maybe totally dissimilar—in and through his

own curatorial practice? One reads time and again that Obrist is an exceptional curator. I agree with that. And I think that he is exceptional because he is exceptionally serious and self-reflective—both in curating, and in realizing not so much the artworks themselves, but rather the life projects articulated by these artworks.

An Obristian
Phone Call

Bruno Latour

Like probably more than five thousand academics, art-
ists, thinkers, activists, it is by a sudden phone call that
I was approached by a certain Hans Ulrich Obrist, who
was not yet the HUO trademark of universal praise. I was
beginning to despair of my ability to understand contem-
porary art and I had sort of toyed with the vague project
that the only way to "get it" was to "do it." But since I was
not an artist, it was the curatorial skills that I was con-
templating from afar. When around 1997, I got a call out
of the blue from a curator, at the time lodged in the
Musée d'art moderne de la ville de Paris, "to simply
discuss *We Have Never Been Modern*," I did not wait a sec-
ond to accept his invitation (in general with HUO you
should never wait more than a few seconds because he
might have disconnected and reconnected with someone
else). The reason I did not hesitate is that this book had
appeared five years earlier and not a single academic
in France had even mentioned it to me. I immediately
learned that the originality of Hans Ulrich was that he
could establish a link between philosophy and art as no
one else was able to do in France at the time.

We had a nice conversation and when a few months
later he called me again to participate in this memorable
"Laboratorium" exhibition qua experiment, I jumped at
the occasion to learn the skill of curating and to have lots
of time to discuss with contemporary artists how they
work and how they develop their ideas. After scientists,
engineers, and lawyers, it seems essential to me to under-
stand artists' unique mode of existence, and I had been
primed in this research by my long friendship with the
great English artist Adam Lowe.

In the meantime, I had met Peter Weibel and I had
toyed with the idea of doing an exhibition about icono-
clasm—as opposed to an iconoclastic exhibition! To my
total surprise, Weibel who had just accepted the new job
of ZKM director had immediately said yes to my mad
project. I just as immediately enrolled HUO just in the
way he had enrolled me in his "Laboratorium" project.
This is where we invented what I then called a *Gedanken-*

ausstellung (thought exhibition), an expression patterned on the model of what historians of science call a *Gedanken-experiment,* or thought experiment—when scientists are unable to really do an experiment in their laboratory but nonetheless do it in their head, so to speak, thus anticipating the future results they will get once the technology of their instrumentation will have caught up with their ideas.

For me the marvelous consequence of being one point in the many relays of HUO—or perhaps I should say, one actor in the *actor-network* that now bears the collective name of "HUO"—is that it opens the possibility of multiplying the occasions to hold thought exhibitions. As we can see through the documents and stories assembled in this book, it is really the whole artwork that HUO has turned around to connect with the academic sphere. Many academics, who without his endless connecting activity would not have had the occasion to leave their ivory tower or to feel the delight of opening an exhibition, are full of gratitude to have hooked into his network.

Of course, this endless connecting activity does not come without a price. You might be enjoying a vacation, when suddenly your phone will ring and a very excited Obristian voice will tell you that you "absolutely have to talk" to some character he is in conversation with whom you have never heard of—it might be an Amazonian Indian activist he has just met, an old scientist, a well-known architect, a politician, etc. The embarrassment comes when, after a split second, you are directly connected with this "immensely important person" you should absolutely talk to and "who is doing such exciting things." And here you are, mumbling a few sentences trying to rack your brain to remember what this famous person has achieved. What counts is that you are now connected and that in your neuronal network another HUO link has been burned for good, waiting for another occasion to meet—an interview, an improvised lecture in Venice, one of the many books HUO writes, and so on.

But the price to pay is worth it, because if you find yourself drawn into the most bizarre situations—having

to lecture at the Venice Biennale with Christian Boltanski's dogs barking and a soprano singer behind you—the energy developed and the number of contacts you've made will keep you busy (and, yes, also dizzy!) for a whole week.

The most amazing thing about Hans Ulrich is that behind this endless connecting activity and his frantic lifestyle, he is first of all a generous friend. The HUO trademark has not altered this quality of his and I have never proposed him a project, no matter how mad, that he did not immediately approve and push forward with a great smile and "Yes, of course!"—jumping immediately to his phone to put me in touch with new people I have never heard of, and who have never heard of me, but who will now be on the receiving end of his famous Obristian phone call ...

Short
Definition
of the
Impresario

Adam Thirlwell

I know that one of HUO's favorite self-descriptions is
impresario. And for a while now I've been thinking about
this word. Superficially, its aura may be spectacular,
but it conceals larger themes. In its most sober sense,
it simply means someone who organizes public entertain-
ment. But I'm not sure this is an accurate account of the
way HUO functions. His work is not official work. I guess
the word acquired a more intellectual sense with Sergei
Diaghilev and his Ballets Russes. They were public
entertainment, sure, but they were also miracles of col-
laboration. With Diaghilev, there begins an idea of the
impresario as the organizer of talent. And this, I think,
is the point where an ideal of *mondanité*—HUO with his
many phones, the distribution network, the hurricane
with his constant adjective "urgent"—becomes an avant-
garde strategy. With the impresario, artistic work stopped
being a pure individual endeavor. It became something to
be done in collaboration—where the old idea of a signa-
ture became outmoded. (In other words, Diaghilev is as
important as Duchamp.) It's an idea that's still so strange,
it comes with its own jokes, like that famous anecdote of
Diaghilev's meeting with King Alfonso of Spain: "What
do you do in the company?" Alfonso asked. And Diaghilev
replied, "Your Majesty, I'm like you. I don't work. I do
nothing. But I'm indispensable."

But what is this work that is at once nothing and
indispensable? It is a way not of signing works but of
influencing their gestation. And its basic premise is that
the thinking that goes into a work of art does not need
to be done singly. There's something Philippe Parreno
says about collaborations, that they make him think
faster. I think that's what HUO does—he makes people
think faster. This is his revolution in the way art gets
made. The model of the lone artist has so governed our
conceptions that it's both disturbing and a relief to have
this new model of sociability proposed by HUO. It allows
for new ways of thinking within the work of art—a work
that is suddenly permeable to all the other aspects of
human knowledge, from biomedics to computer

programming—and also new ways of thinking about how
a work might saunter out into the street. Sociable in its
making, the work of art is also sociable in its presence
in the world. It is ephemeral, unfinished: something that
exists in the moment of its perception by a mobile audience.

Now, this perhaps might seem similar to the older ideal
of the Gesamtkunstwerk, the total work of art. That ideal
is most associated with Richard Wagner, and his theory
that the true Gesamtkunstwerk was his new model of opera.
For Wagner, the total work of art was a performance. But
Wagner's idea of a performance was the pure individual: the
absolute Wagnerian. Whereas HUO's ideal of a total perfor-
mance—where any art can be combined with another—is
something more utopian, less totalitarian. The first book
HUO ever sent me was a copy of his dOCUMENTA (13)
piece with Édouard Glissant, and in his introduction he
mentions Glissant's ideal of archipelic thought: "Conti-
nents reject mixings [... whereas] archipelic thought makes
it possible to say that neither each person's identity nor the
collective identity are fixed and established once and for
all. I can change through exchange with the other, without
losing or diluting my sense of self. And it is archipelic
thought that teaches us this."[1]

That's the kind of thinking that the impresario can
teach us—and I wonder if I cherish this ideal particularly
because I am a novelist. The novel, it seems to me, is one
of the least modern art forms in current existence. But
the ways HUO makes me think, with his proposals and
suggestions and friendships, offer ways of imagining how
art and literature can exist in friendly cooperation, how
a novel can be made more sociable: a performance explor-
ing the time of its own reading, a traveling exhibition.
The main way a novel exists, after all, is by occupying
time. And when you begin thinking like this, it may be

1. Édouard Glissant, quoted in Hans Ulrich Obrist, "Le 21ème siècle
est Glissant," in *Édouard Glissant & Hans Ulrich Obrist*, dOCUMENTA (13):
100 Notes – 100 Thoughts (Ostfildern: Hatje Cantz, 2012), 4. See also the
second volume of this series: Hans Ulrich Obrist, *Sharp Tongues, Loose Lips,
Open Eyes, Ears to the Ground*, ed. April Lamm (Berlin: Sternberg Press,
2014), 31–36.

possible to imagine fictions that are equal to the twenty-first century. The impresario (HUO) makes me hopeful for the future.

Cities on the Move, Twenty Years On

Wong Hoy Cheong

I.

When you google the phrase "cities on the move," the first search result is linked to the energy and technology company Siemens. The overview on its home page states that urban communities will face explosive growth and collisions of forces, and how the company can offer cities "strategies and tools to ensure that they will become social, cultural and economic hubs." The second search result is a 2015 event titled "Cities on the Move" organized by the New Cities Foundation. It convened thinkers, designers, and planners to discuss issues of urban infrastructure and mobility. Another search result is a 2002 World Bank report, "Cities on the Move: A World Bank Urban Transport Strategy Review," focusing on the sustainability of urban transport with an emphasis on equitability and accessibility for the poor. The rest of the search results point to various websites directly or indirectly linked to writings and archival information on the exhibition "Cities on the Move" (1997–98).

However, it is the three results I mentioned that interest me the most. I find it uncanny that the phrase "cities on the move," used by Siemens, the World Bank, and an NGO should encapsulate ideas and issues not dissimilar to those put forward in the "Cities on the Move" exhibition mounted twenty years ago at the turn of the last century—namely, that cities are catalysts for innovation, transformation, and contestation, as well as sites for sociocultural ferment, discourse, and engagement.

II.

Sometime in early 1997, if I recall correctly, I received an email from Hou Hanru and Hans Ulrich Obrist informing me of a project they were working on. They told me they would be coming to Kuala Lumpur.

During the visit, Hanru and Hans engaged with artists, writers, architects, and opinion makers, asking questions and gathering information. In between and after meetings, we drove around Kuala Lumpur with

wide-eyed wonderment and bemusement, soaking up the showy outcomes of the economic-boom years in Southeast Asia. We visited the streets of the old city, with its bustling Chinatown and Indonesian and Nepalese immigrant traders; the just-completed shimmering glass-and-steel César Pelli–designed Petronas Twin Towers punctuating the haze-filled sky; the prizewinning bioclimatic tower by architect Ken Yeang, rising up solitary by the highway, on a large, empty plot of land; and a newly opened hotel and shopping mall, capped by a sand-colored pyramid and heralded by a six-story-high lion-headed sphinx at the entrance, where we savored the most enormous tiramisu I had ever seen.

Mid-1990s Kuala Lumpur, like many Asian cities, exuded optimism and dynamism. It thrived on new money, opulence, and an assured sense of economic and social mobility for all those who flocked here. New high-rises, banks, highways, flyovers, and even a Gotham-like capital city rose from cleared oil-palm plantations and peat marshes outside of Kuala Lumpur. Relentless piling, construction, and traffic jams clogged the roads; and up to two million legal and illegal migrant workers from other Southeast and South Asian countries came to seek a better life. Malaysia roared arrogantly, and was catching up with the Four Asian Tigers: the newly developed economic powerhouses of Singapore, South Korea, Taiwan, and Hong Kong. "Malaysia Boleh!" (Malaysia can!) was the catchphrase of the generation. "Asian values" was the ideological posturing, affirmed by the Bangkok Declaration of 1993 and passionately propagated by Malaysia's prime minister Mahathir Mohamed and Singapore's prime minister Lee Kuan Yew, both septuagenarians at the time.

The first permutation of "Cities on the Move" emerged at the Vienna Secession, with the heightened, hypermaniacal, everything-is-possible fervor of the 1990s on full display. Unfortunately, by the time the exhibition opened in late 1997, that optimism and joie de vivre had evaporated. Asia was in crisis, in a state of financial meltdown.

One after another, currencies, economies, and markets tumbled spectacularly. Fortunes vanished. Banks collapsed. The economic bubble had burst. Doom and a foreboding sense of unrest permeated much of Asia, soon to erupt in violent proportions in Indonesia and Malaysia over the years that followed.

III.

In 1897, one hundred years before the "Cities on the Move" exhibition, the Vienna Secession was founded by a group of Austrian artists, sculptors, and architects who had resigned from the Association of Austrian Artists. Above the entrance of that iconic building is the phrase "Der Zeit ihre Kunst. Der Kunst ihre Freiheit" (To every age its art. To every art its freedom).

It is no coincidence that "Cities on the Move" was first installed at this venue on the eve of the hundredth anniversary of the Vienna Secession. The exhibition curators posited their own form of rebellion and "secession," particularly in terms of curatorial imagination and objectives, and in how the exhibition was designed and installed. Rethinking the entangled relationships among different art trajectories and their engagement with urban economies, daily life, and the city was especially crucial.

The gallery space was transformed into a laboratory for experimentation. Over one hundred works were installed in the airy hall, each held in constant tension by a metal scaffolding structure, with a mezzanine floor designed by Yung Ho Chang. The works on display include talking durians, a jockey golf course, intricate toothpick structures, sleeping pods, a *tuk-tuk*, a catapult on a bicycle, architectural models, sculptural photographs, decorative lights, pickled vegetables, plastic utensils, and toys. Works conversed and clashed with each other in a cacophony of forms, sounds, and sensations. There was a palpable sense of relentlessness in the exhibition. It was overwhelming, with little respite. Navigating through the exhibition became a heightened

sensorial and physical experience, not unlike negotiating many a city in Asia, particularly one with "post-planning" developments, as postulated by Hanru some years earlier in a conference in Shenzhen, China.

There was vigorous debate among those who were involved in and those who saw this first permutation of "Cities on the Move." It was an experiment that provoked strong opinions. Some artists were infuriated by the inability to view their artworks without being obstructed by other installations. A few even withdrew from the project along the way. Critics were perplexed and yet curiously captivated by the curatorial selection and strategy. The exhibition was both condemned and praised. Some museum professionals were aghast at the cluttered display, and opined that it would be inconceivable to mount such an exhibition within their galleries. Yet, despite the mixed bag of reactions, "Cities on the Move" generated an unprecedented interest in the art community, and traveled to six other locations: MoMA PS1, New York; CAPC musée d'art contemporain de Bordeaux; the Louisiana Museum of Modern Art, Copenhagen; the Hayward Gallery, London; Kiasma, Helsinki; and various venues in Bangkok.

Over the next two years, the curators and artists experimented with new strategies as they closely followed the unfolding sociocultural, economic, and political crises in Asia. The project mutated and reinvented itself with each venue; there were new commissions and artists, new groupings and themes. At the Hayward Gallery, the the structure of a previous exhibition on Russian avant-garde fashion design was half demolished and then de-/reconstructed by Rem Koolhaas and Ole Scheeren as an exhibition space. In Bangkok, the city sprawl itself became a site for the experiment.

IV.

The last installation of "Cities on the Move" closed in Helsinki in January 2000, amid relief that the millenial Y2K bug had not wreaked worldwide havoc as technology soothsayers had predicted. Asia underwent massive changes over the years spanning the inception of the exhibition in 1997 and its conclusion in 2000. Governments fell in South Korea, Thailand, and Indonesia. The World Bank and the International Monetary Fund bailed out and helped restructure economies in Asia. Hong Kong was returned to China. The Reformasi (Reform) movements in Malaysia and Indonesia resulted in moral and political crises in both countries, with detentions and thousands of deaths in the latter. The rhetoric of so-called Asian values so fervently advocated by autocratic leaders had dissipated. "Cities on the Move," which had premised itself on pre-crises maniacal optimism, could neither foresee nor avoid the waves of political and financial tumult enveloping Asia.

What differentiated "Cities on the Move" from other blockbuster exhibitions was that it engaged with the city as both a site and a catalyst. It recognized the indomitable march of technology, globalization, and migration; and the emergence of Asia as a new cultural, economic, and political player. It was an exhibition which was borne of and fed off the optimism and anxieties of the turn of the twentieth century. It straddled the shift between analog and digital, the fax machine and the email, the landline and mobile phone. "Cities on the Move" captured that zeitgeist, the tense and palpable zone of flux between two centuries where the urgent needs of the present became inextricably intertwined with dreams for a utopian future.

Between Nothing and Infinity: Brief Encounters with HUO

Raqs Media Collective

0.

It is a truth now universally accepted that the earth
spins once around its axis in twenty-four hours. Most
of us take advantage of this diurnal rotation to alternate
between light and dark, between sleep and wakefulness.
But for some, the fact that the world turns is no reason
to not stop spinning. It is for them that eyeshades and
electric lights were invented. For them, there is no night
any longer, nor is there ever day. Instead, it dayglows
into nightshade.

Hans Ulrich Obrist is not a creature of the day or of
the night. He is a citizen ambassador of distant twilights,
of further dawns. The eternal late afternoon or mid-
morning of his spirit hides a secret antidote to the jet lag
of our time. Wherever he is, it is arrival.

So, here are six elliptical accounts of encounters
between Raqs and Hans Ulrich that took place each time
between some landing and some takeoff, in the vestibular
transit lounge of our intersecting mental terminals.
Each meeting is a parable, a parabola, an arc ascending
from arrival.

1.

First encounter with this envoy plenipotentiary of futu-
rity occurs in the second year of the twenty-first century,
just after documenta 11. There is a crowded corner table
with an anglepoise lamp in a backroom of the Palais de
Tokyo in Paris. And at that corner table, between papers
and Post-its, sits Hans Ulrich.

The meeting is brisk, the questions pointed.

What made our minds tick? Who were we talking to?
Who listened to us? Who were the most interesting
thinkers, scholars, architects, visionaries, scientists,
mathematicians that we knew of at that time in India?
What kept us awake? What did we fight about? What
did we desire? What kept us going?

The interview does not turn visitors into available
"native informants." There is no grand inquisitor with
a black notebook. Questions are met with questions.

In this rapid-fire reciprocity, our stories of conversations in Delhi are met with accounts of discoveries in Zurich. There are accounts of kitchen-sink exhibitions, and suitcase-shows; of showing up at the doors of older men and women, without passport or permission; of discoveries and disavowals; of artist-pioneers and forgotten thinkers. There is a story of being taught fractals by Benoit Mandelbrot that makes its way into a book we are making, there is a memory of being shown the door by Stanislaw Lem when Hans Ulrich made the mistake of mentioning a "stalker" called Andrei Tarkovsky, and so on.

Our wires plugged in, we listen and speak, and sense that this is not an ordinary first encounter. A mental note is made. There is such a thing as the everyday urgency of curatorial investigation. It's not about projects; it's about life.

Hans Ulrich Obrist invites Raqs to board the next train at Utopia Station. Unreserved.

2.

Some years later, 2007?

In a restaurant up many flights of stairs in New Delhi. Obrist comes across goat meat for the first time in his life. Doesn't bite, but watches us dig in, fascinated by the alien aroma. The conversation is as thick as the curry on the table. Our description of the rich, strong taste of the meat turns thoughts in the direction of other abundances.

What is the taste of life? How do artists savor experience? Hans Ulrich remembers the keenness with which the artist Asger Jorn silently and single-handedly supported the Situationist International's publications and lifestyles. We recall meeting a remarkable anthropologist who grew up with Jorn as a father figure, and she had spoken to us of his incredible energy and openness, and his interest in Japanese geometry. Obrist concurs, reminiscing about Jorn's curiosity in medieval manuscripts and his efforts at restoring them. We marvel at Jorn's temporal ambidexterity, his ability to articulate

a radical and contemporary sensibility while appreciating
a tradition's strength. Jorn was a man simultaneously
ahead of and behind his times. He was generous with time.

Our conversation wanders to consider the shape
that curiosity can take in our times. What does it mean
for artists today to marshal resources, time, talent,
wisdom, and money? Can artists twist and inflect the
presence of wealth in specific, surprising and unprece-
dented ways? Will this become an artistic and curatorial
imperative in coming times?

3.

Autumn 2008: It's most urgent because of all the words
we are writing, says the excited voice of Hans Ulrich who
considers our visit to his Serpentine office an opportunity
to ask more questions.

What's happening with all the things Raqs is writing?
Why aren't they in one place? What could be the title?
There must be a book. There must be a library of books.
The archive is a living thing, a tree, not a graveyard.

We will connect on a conference call.

Hello-Hello. It's very urgent. Hello Berlin-Sternberg,
this is London-Obrist, connecting Delhi-Raqs. It is *most
urgent* that all Raqs notes, communiqués, and *latentos*,
and other nonmanifestos be collated in a single publica-
tion. We must all do what it takes, because otherwise there
will be no seepage between Raqs's thinking and the seized
opportunity of a global readership, *ja*? Over and out.

There is a book. There is a title. There is "seepage."
There is an entry in the card catalogue of the library
of forking shelves. There are readers. There is a man who
scans everything that can be written and reads the rest
with Post-it notes. There is a new notch, a new groove, in
a hive mind–memory bank. Somewhere a neuron lights
up and electricity jumps across a synapse to a new thought.

Carpe lector. Seize the reader.

4.

Frieze 2010: We are passing through London, detained

by an afternoon's speaking engagement in a very big tent.
Meanwhile, it's raining imperatives. Obrist is running
another Marathon. Manifestos that go the distance.
All sorts of proclamations. Do we have one? By when?

It's not a manifesto, strictly, it's a latento, sort of
the opposite of a manifesto—a *Communist Latento*—in
which there is a thought about being neither the arrow,
nor the boomerang of time.

Will we read it aloud?

We never have.

The Marathon is about to begin in an hour. Would
we consider a last-minute entry? It won't take long.

When it rains imperatives, it rains imperatives.

We read the *Latento* in the pavilion at the Serpentine.
Last-minute surprise entry. Entering left field into an
already crowded program.

This presents a conundrum.

What are a last minute and a last mile in curatorial
thinking? How does one become attentive to the instant,
the split second, and still be a long-distance runner?

5.

A possibility of time travel in our lifetime raises its head
during another conversation in London with Hans Ulrich.
We were sitting below the rising curve of *The Arc of the Day*,
our assemblage of thirteen clocks set to the longitude of
some real cities, like Dehli or Dakar or Detroit, and a few
imagined ones, like Macondo or Shangri-la or Rummidge.
They spanned the hours from epiphany to anxiety to
nostalgia on their faces. Rummidge is the literary mirror
of Birmingham, whose city limits fall within the pages of
David Lodge's novels. If Birmingham were to be a station
in the mind, it would be called Rummidge. How long
does it take to travel from a city on earth to its literary
doppelgänger?

One of us mentions that our meditations on time
and the future have one beginning in a text we wrote for
a conference in Birmingham University sometime in 1999.
In 1999, when the internet was young, and this century had

not yet dawned, we wrote a text that looked at the rela-
tionship between knowledge, the internet, the new
economy, and a gendered division of labor—and which
featured a set of delirious dialogues between sages,
robots, and rebel women.

Obrist, excited by any aesthetic of connection, and
a new enthusiast of all things Birmingham is very taken
by the possibility of having another "urgent" conversation.
His phone dials David Lodge. A hasty meeting is arranged
(and recorded on radio) under the shadow of a clocktower
in Birmingham.

As with so many things that one plans with Hans
Ulrich, we mark this face-off with a Post-it, or postcard,
addressed to the future, franked to an address in a
shadow city, first exit left from a highway that speeds
onward to another time. As it happened, we had to fly
out before Epiphany rendezvoused with Nostalgia.

6.

Hans Ulrich is calling. He is not distraught, but his voice
has a different tone. A slight deceleration. He calls to talk
about death. The man who has chased old men all his life
has seen his first dead body. Maqbool Fida Husain, age-
less, serene, in a shroud, no longer walking barefoot, lies
still in a London mosque. HUO has read an obituary that
one of us has written on a blog.

We talk about an afternoon on an Indian Highway
in the Serpentine. Husain has gone AWOL. His family
is frantic. One of us had just taken his photograph so we
are asked where he is. Obrist is worried. What if the most
eminent living artist of the Indian subcontinent disap-
pears in London under his watch? Where did he go after
the photograph was taken? He just got up and left, we say.

Just got up and left the building. Exited the exhibi-
tion through a side door. This is also a way in which an
artist can take his last and final call.

Every artist leaves something behind which wasn't
there on the planet before she thought of it in her head.
The curator recognizes that this thing that the artist

places on the horizon of our consciousness says something infinitely new. This can happen once, or often, or even just before you have taken stock, or decided to take your final call on things.

The life or death of an artist is not necessarily an event of historic dimensions. It can be, and usually is, an ordinary matter of checking in and checking out of the hotel of the world. But while she sojourns, the artist marks her time with a degree of acuteness. From each according to their whimsy, to each according to their passion. The curatorial consists of taking the measure, and then custody, of the difference between whimsy and passion. In Hans Ulrich's voice that afternoon was a sense of that remainder, and the sense of what it means to be a custodian of what remains in memory, occasioned by his first glimpse of an actually dead person.

Here was a former master, now just a body. Like any body, and every body. Here was a curator, brought face to face with everybody's mortality, including his own.

And the Marathon has to keep going.

∞

An Afterthought
How do we learn to sprawl across histories without losing attention and empathy, when sources and influences are discovered, added, subtracted, prized open, made unstable and scrabbled?

If one were to draw a map of the congruencies and conflicts between the conscious and subliminal forces that tug at our imaginations, affinities, and reasons—while taking account of the tectonic movements of the geopolitical realities of our times—what kind of picture, and what kind of terrain would be revealed?

How do these coincidences (of the hunger that comes after a long journey, the taste of goat meat, the chance encounters between different people, the urgent phone calls and endless Post-its) confront the delirium and disrupt the routines of our time?

Mobile Positioning

Why Hans Ulrich Obrist is not a curator of
contemporary art. Why Hans Ulrich Obrist is not
a critic of contemporary art.

Stefano Boeri

1.

We are presently experiencing a period of great productivity and great hypocrisy in the field of contemporary art. A hypocrisy that above all concerns the division of roles among production, criticism, and curatorship.

As we know, the criticism and curatorship of contemporary art are supposed to be based on a common *order of discourse*, which is what distinguishes them from the sphere of artistic production. It is an order of discourse that functions according to the two great practices of *the delimitation of boundaries* and *classification*. Both, in fact, are called upon to include and exclude authors, works, places, and institutions within categories of value and degrees of excellence.

The critic of contemporary art is supposed to establish the *ontological* realm in which something new has occurred or is occurring. Within this sphere, he is supposed to constitute families, trends, and perspectives; observe the development of the artists and their works; and grasp and attest the phases of that development, its sudden swerves, declines, and gaps. In short, his task is to historicize the present.

The curator's order of discourse, by contrast, is supposed to be based on a fundamentally *geographical* criterion. The curator is supposed to circumscribe the territories in which new forces are at work, follow and guide the trajectories of artists, construct spaces in which audiences can encounter works of art and generate exclusions. In short, his task is to create hierarchies of places and institutions.

To summarize: the criticism of contemporary art is supposed to circumscribe and classify at the level of present *history* that which curatorship is supposed to circumscribe and classify at the level of present *geography*.

In fact, however, this is not how things actually stand. On the contrary, for some time now these two domains have been in the process of becoming more and more superimposable and superimposed, so that at this point they are virtually synonymous. Among the territories

of contemporary art, curatorship has absorbed the role
of criticism, and criticism has stretched to the point
where it occupies the field of activity of curatorship.

But there is more: the nature of the sphere of the
production of contemporary art has changed today as
well. It has annexed the bases of criticism and curatorship.
From Andy Warhol to Dan Graham and from Alighiero
Boetti to Matthew Barney, art has gradually become
a delocalized and self-reflexive practice that eludes
geography and purports to historicize itself. The artists
move within a global and extremely broad terrain that
affords them increasing opportunities to exhibit their
work (biennials, fairs, anthological exhibitions, retro-
spectives) and where trends and tendencies spring more
from an artist's *positioning* within a particular event than
from a classification of genres and poetics. In fact, as is
often pointed out, from this perspective every artist is
potentially the author of his own criticism and the cura-
tor of his own work.

But however glaringly obvious it may be, this funda-
mental confusion of identities, expectations, and func-
tions continues to be anesthetized and suppressed. Still
adrift on this sea of dissolving boundaries are rigid
professional roles and constituencies codified according
to anachronistic codes and institutions. Curators who
pretend they are only curators call on artists who pretend
they are only artists to produce works of art to submit to
the judgment of critics who pretend they are only plying
the critic's trade. These roles formally divide up a field
of practices fundamentally unified by the dissolving of
generic differences.

2.

It is impossible to understand the work of Hans Ulrich
Obrist if one ignores the importance of this productive
confusion and the hypocrisy that continually conceals it.
In spite of his "formal capacities," Obrist is neither a cura-
tor nor even a critic of contemporary art, despite the fact
that he moves within the order of discourse on which both

of these disciplines are based and agrees to take on roles and identities dictated by their respective spheres of activity. Obrist is not a curator nor even a critic—he simply works on the presently existing state of affairs. Obrist does not delimit or classify artistic geographical fields or spheres of activity. Instead his work revolves around the concept of *positioning*. Obrist positions himself—that is, his body—within the force field of contemporary art, and he does so in order to intercept and modify the scattered materials that make up the sea of "dissolves" in which the boundaries between roles are melting away. Obrist projects the movement of his body throughout the world, and thanks to it he encounters artists, works, reviews, exhibitions, articles, institutions, events, journals, collections, dealers, journalists, archives, schools, installations, museums, performances, seminars, conferences, conventions, workshops, Kunsthallen, gallery owners, and politicians, all of which constitute the materials of global contemporary art.

Obrist's arrangement of these materials springs from the encounter between them and his body-sensor. It does not respond to a criterion of delimitation and classification—established a priori or redefined after the fact—but instead corresponds to a *labor of artistic production,* one that is arbitrary and changeable, temperamental and omnivorous, and obsessive in its all-encompassing reach: Everything deemed notable must be noted, and everyone must be sought out and interviewed. Everyone: artists, architects, philosophers, institutional representatives, filmmakers, politicians, scholars, poets, students, photographers, and even mere witnesses. Obrist has been working for years on a global *artwork* of the scattered materials of contemporary art. He is working on the existing state of things with the obsessive single-mindedness of one who knows that he cannot help but travel its entire length and breadth, and he is waging a utopian struggle—and this is indeed a utopia in its pure form—against amnesia. A battle to diminish the enormous, growing, and inevitable distance between (individual) memory and (collective) history.

As the ultimate form of body art, *mobile positioning*—the subjective and mobile interception of artistic practices and experiments—is a necessary and (at least in part) unwitting precondition and strategy of any rigorous effort to work in the sea of contemporary art. Thanks to the brilliant and transparent arbitrariness of art, Obrist's work is not only a salutary stocktaking of the existing state of things—it is also a revolutionary condition for overcoming it.

Two or Three Things I Know about HUO
Afterword by Manthia Diawara

I must have met HUO in 2008, at the eightieth birthday
celebration of Édouard Glissant, at the nightclub New
Morning in Paris. I also saw him from a distance around
the same time, at agnès b.'s art foundation, for another
event in honor of Glissant, upon the publication of his
book *Philosophie de la relation* and the presentation of
Glissant's published drawings by Hans Ulrich Obrist.
The birthday celebration at New Morning was particu-
larly intense because of the lineup of renowned poets,
musicians, politicians, curators, and public intellectuals,
including Lilian Thuram, Laure Adler, Dominique de
Villepin, Christiane Taubira, Edwy Plenel, and Patrick
Chamoiseau, et al. But I remember Glissant calling me
out in the crowd that night, and introducing me to Obrist
as someone who could help me with the film I was mak-
ing about him. Glissant had urged me to meet HUO,
whom he described as "un garcon très intelligent que
tu vas beaucoup apprécier!"

I must confess now that I said to myself, that night
at the birthday party, not without a slight feeling of envy,
"So this is the Hans Ulrich Obrist that Édouard so wanted
me to meet!" But, as if he had guessed my thoughts,
Obrist shook my hand, saying, "So you are Manthia
Diawara! Édouard told me so much about you. Finally!
I am very happy to meet you!"

Still, I was curious about what Glissant saw in Obrist
that was so special. Why was the philosopher I most
admired nudging me toward a curator, instead of another
Glissant scholar? And you can bet that I asked Édouard
that question after the party, as soon as I was alone with
him. I knew that HUO had already done several interviews
with Glissant, which he offered that night to share with
me, to use for the film I was making on the Martinican
poet-philosopher. I was also aware of the fact that Glissant,
and agnès b. had asked HUO for advice on how to realize
Glissant's long-held dream of a museum in Martinique that

173

could later become nomadic. Finally, as I have already
mentioned, HUO had published drawings by Glissant.

Still, Édouard was not surprised by what now seems
an impertinent question: "Qu'est-ce que Hans Ulrich Obrist
apporte de special à la compréhension de ton oeuvre?"
He said that what was unique about HUO was that he was
one of those rare curators who knew how to visualize the
imaginary of an artist, not as something static that had
to be understood by the viewer, but as a fluid process
that enters into a relationship with the imaginary of the
onlooker, and opens up the doors to new possibilities of
visualizing the world, of multiplying poetic and "creol-
ized" intentions in the world—instead of reducing every-
thing to a single and uncontaminated meaning.

I could see that Glissant was describing HUO in the
way that he wanted people to understand his own work
in the future. Glissant believed that the Western world
was mistaken if they believed that they could fight terror-
ism with more terror and more security. He used to tell
me that, in the long run, the most potent weapon against
terrorism was to attempt to change the imaginary of the
future subject of a terrorist strike: an effort aimed at
providing him or her with a feeling of empathy toward
his or her intended victims that is equal to the motives
and goals of his or her desire to commit a senseless act
of violence against them. He said that HUO had under-
stood that power of the imaginary in art; that his curato-
rial activities consisted in working to liberate people's
imaginaries, relationally to other imaginaries of the
world. What he liked about HUO was that for him it
did not matter whether he was dealing with high art or
popular art, philosophy or literature, architecture or
performance, as long as they were all traversed by poetic
intentions, intuitions of the world we all share, no matter
how far apart we are.

HUO's role as a curator is to connect these intuitions,
to relay their stories to one another, and to the world, no
matter their opacity to one another—and to us. In other
words, HUO knows that the curator has always to perform

a ritual through a mise-en-scène that is endowed with visual and invisible energies, for the purpose of releasing multiple structures of feeling. For all these reasons, a curator has to learn to tremble with the trembling of others, no matter how far removed from them in time or space he or she is. To paraphrase Glissant: The capacity to tremble with others prepares us to meet the unpredictable and the uncertain. Some keywords for knowing HUO are therefore found in his capacity to create a solidarity between the imaginary and Glissant's quakeful thought (*la pensée du tremblement*).

I have come to know Obrist better since that birthday party, and I now understand what Glissant meant by his unquenchable capacity to tremble with others. Sometimes I wonder if HUO ever disconnects from the world's trembling, from Dakar to Jakarta, Beijing to New York, and back to Athens and London? He is everywhere, cultivating, or should I say curating, people's desire for art, the only true miracle. HUO has become a magnet that attracts the most diverse people to him wherever he goes. I remember one time running into Booker Prize–winner Ben Okri at the Serpentine Galleries' 2016 "Miracle Marathon"; when I told him how surprised and happy I was to see him, he simply replied, "How can you say no to Hans Ulrich?"

I had the privilege of participating in another event in Paris, curated by HUO with Daniel Birnbaum and Philippe Parreno for the LUMA Foundation, titled "Resistance"—which, as HUO said in his opening remarks, was the leitmotif for a never-realized exhibition by Jean-François Lyotard. Whereas the "Miracle Marathon" was comprised of artists, creative writers, poets, and shamans, the "Resistance" gathering was biased toward philosophers, environmentalists, and activists, including some of my favorite people: Gayatri Chakravorty Spivak, Étienne Balibar, Jean-Luc Nancy, and Jennifer Jacquet.

The most moving moment, or I should say "trembling instance," at the "Resistance" meeting was when Spivak sang Boris Vian's "Le déserteur" for Nancy as a gesture

of their reconciliation, following a long period of mis-understanding between the two. Spivak told me that she knew how much Nancy loved the song, which was a protest song against the war, written to President Charles de Gaulle. It was for me a real Glissantian moment about truth and reconciliation, which had me trembling at every word from Spivak's mouth. Lyotard would have been proud of her singing, in flawless French, as a tribute to his exhibition.

Finally, and now that I can call HUO my friend, a few words about the ludic side of the curator; I am now talking about the HUO who has time to play, to gamble, win, or lose, while laughing. I am sure that some readers, more familiar with his serious public demeanor, will be surprised by this childlike quality of the man without that mask, who visits New York galleries à la Jacques Rivette's *Céline and Julie Go Boating* (1974) or in Arthur Rimbaud's "Le bateau ivre" ("The Drunken Boat," 1871). I had heard the Surrealist saying, "L'aventure est au coin de la rue" (Adventure can be found at any street corner), but I found out the true meaning of the expression at my own expense: A few months ago, HUO was passing through New York City and he asked Asad Raza and me to meet him and talk about an exhibition he and Raza were curating on Glissant, at Villa Empain in Brussels. HUO and Raza suggested that we meet first at 10 a.m., see some galleries in Chelsea, and have a lunch meeting in the cafeteria of the New Museum, where we could then see the new Raymond Pettibon show.

Up until that time, my special encounters with HUO were confined to museum and gallery settings and dinners with artists, philanthropists, art critics, and other curators. So it was fair to say that HUO and Raza did not know me enough to realize that I hated visiting gallery and museum openings in New York, because they are never-ending, like the "breaking news" on cable television. I always told myself it was because I was lazy, or not motivated enough by the newness of the new shows.

I told HUO and Raza that I was tied up all morning and that I only had time to meet them in the cafeteria of the New Museum, to talk about the Glissant show. So we agreed to meet at 3 p.m. in the cafeteria, after they had seen the new show in the museum. I was pleased with myself because I thought that I had succeeded in avoiding the gallery and museum visits, without hurting my friends' feelings.

But I had underestimated the ingeniousness and determination of HUO. By 4 p.m., he looked at his watch and said that there was a show of Kader Attia, around the corner that he'd like to see with me, if I did not mind, because he had remembered an article I had written on the Algerian French artist for *Artforum*.

The first thing I noticed about HUO was that he did not look at the Attia video installation like museumgoers usually do, that is, from the quattrocento one-point perspective. First, he looked at the positioning of the wall text for every piece and then looked at it from several viewpoints, before commenting to me and Raza how well the installation was done. Finally, he looked at the art and made further commentaries, before signing his name in the guestbook on the way out.

It was raining and windy that day, and we only had one umbrella. I remembered from the cafeteria that HUO had a reddish wool sweater with a black image of an animal stitched on the chest. I had on my big leather hat, so I told Raza to share the umbrella with HUO, because I was worried that his sweater might get wet, even under the coat he was wearing.

I don't know how, but that's when my *Céline and Julie*–like adventure began with HUO and Raza, after we visited the Attia show. It was amusing to me how HUO and Raza treated the area south of Houston Street (SoHo) as a terrain in which we had to play hide-and-seek, from gallery to gallery. Because we were always getting lost between galleries, we started playing a game of whose directions will lead us to our destination first, or get us lost. Asad was mostly winning that game; I am very bad

at directions, even though I have lived in this neighbor-
hood for over twenty-five years. Then we had to decide
who was taking the elevator or going up the stairs to the
gallery. I found that I was getting lost between the many
galleries in the same building. It was fun, and we laughed
at ourselves and with one another the whole time.

But the best game, our *400 Blows* moment, concerned
the mischievous tricks we played once inside a gallery.
HUO decided that his name would be Asad Raza, who
in turn signed his name as Manthia Diawara in the guest-
book; and I signed my name as Hans Ulrich Obrist. We
played this game, switching characters, like in an Alain
Robbe-Grillet novel, with variations on the roles, at
HUO's whims.

These are two or three things I know about HUO.
And long may he live to reveal more facets of his character
and genius.

New York, July 2017

Credits

Etel Adnan's foreword was translated from the French by James Horton, 2017.

Alan Pauls's "Prologue" was originally published in Spanish as "Prólogo," in *Conversaciones con artistas contemporáneos*, ed. Alan Pauls (Santiago de Chile: Ediciones Universidad Diego Portales, 2015). Reprinted by permission of the author and publisher. Translation by Nick Caistor, 2017.

D. T. Max's "The Art of Conversation: The Curator Who Talked His Way to the Top" was originally published in the *New Yorker*, December 8, 2014. Reprinted by permission of the author.

Jacques Herzog's "For Hans Ulrich Obrist" is an edited transcript of his speech delivered on the occasion of the 2015 International Folkwang Prize, Museum Folkwang, Essen, November 2015.

Excerpt from *Journey to the Abyss: The Diaries of Count Harry Kessler, 1880–1918* by Harry Kessler, edited and translated by Laird M. Easton (New York: Knopf, 2011) is reprinted by permission of Alfred A. Knopf, an imprint of Doubleday Publishing Group, a division of Penguin Random House LLC. © 2011 by Laird M. Easton. All rights reserved. Any third party use of this material, outside of this publication, is prohibited. Interested parties must apply directly to Penguin Random House LLC for permission.

Michael Diers's "'Infinite Conversation' or The Interview as an Art Form" appeared in a slightly different form in Hans Ulrich Obrist, *Interviews: Volume 1*, ed. Thomas Boutoux (Milan: Edizioni Charta, 2003). Reprinted by permission of the author and publisher.

Yoko Ono's quotation was originally published in Hans Ulrich Obrist, *Ways of Curating* (London: Penguin Books, 2015). © Hans Ulrich Obrist, 2015. All rights reserved. Reprinted by permission.

Douglas Coupland's "On Interviews" appeared in a slightly different form in Hans Ulrich Obrist, *Interviews: Volume 2*, ed. Charles Arsène-Henry, Shumon Basar, and Karen Marta (Milan: Edizioni Charta, 2010). Reprinted by permission of the author and publisher.

Bruce Altshuler's "Art by Instruction and the Prehistory of 'do it'" was originally published in a slightly different form in *do it: The Compendium* (New York: Independent Curators International, 2013). Reprinted by permission of the author and publisher.

Sophie Collins's "Zyzio" was originally published on the *Quietus*, March 30, 2014, http://thequietus.com/articles /14877-two-poems-by-sophie-collins. Reprinted by permission of the author.

Daniel Birnbaum's "The Archaeology of Things to Come" appeared in a slightly different form in Hans Ulrich Obrist, *A Brief History of Curating* (Zurich: JRP|Ringier, 2008). Reprinted by permission of the author and publisher.

Wong Hoy Cheong's "Cities on the Move, Twenty Years On" appeared in a slightly different form on *M+ Stories*, November 8, 2017, https://stories.mplus.org.hk/en/podium /issue1-visual-culture/cities-on-the-move-twenty-years-on. Reprinted by permission of the author.

Stefano Boeri's "Mobile Positioning" was originally published in Italian as "Posizionamento mobile," in Hans Ulrich Obrist, *...dontstopdontstopdontstopdontstop* (Milan: postmedia books, 2010). Reprinted by permission of the author and publisher.

Etel Adnan (*1925) was born in Lebanon and spent most
of her life in California, where she taught philosophy while
becoming a poet and a painter. Her novel *Sitt Marie Rose*
(1978) has become a classic of anti-war literature. She has
produced works for theater, starting with the Marseille
section of Robert Wilson's operatic opus *the CIVIL warS: a tree
is best measured when it is down* (1984). Her poems have been
put to music by composers such as Gavin Bryars, Annea
Lockwood, Henry Threadgill, Tania Leon, Zad Multaka,
Ben Ching Lam, and Samir Odeh-Tamimi. Her paintings
are in the collections of museums such as the British
Museum, Centre Pompidou, MoMA, Whitney Museum,
and MOCA Los Angeles. She currently resides in Paris.

Bruce Altshuler (*1949) is director of the Program in
Museum Studies at New York University. He is the author
of *Biennials and Beyond: Exhibitions That Made Art History,
1962–2002* (2013); *Salon to Biennial—Exhibitions That Made
Art History, Volume 1: 1863–1959* (2008); *The Avant-Garde in
Exhibition: New Art in the 20th Century* (1994); and *Isamu
Noguchi* (1994). He is editor of *Collecting the New: Museums
and Contemporary Art* (2005). Altshuler has been director
of the Isamu Noguchi Garden Museum, taught at the
Bard Center for Curatorial Studies, and served on the
board of directors of the International Association of
Art Critics (AICA) United States.

Ed Atkins (*1982) lives and works in Berlin and
Copenhagen. Solo presentations include Martin-Gropius-
Bau, Berlin; MMK, Frankfurt am Main; DHC/ART,
Montreal (all 2017); Castello di Rivoli and Fondazione
Sandretto Re Rebaudengo, Turin; the Kitchen, New York
(2016); Stedelijk Museum, Amsterdam (2015); the
Serpentine Gallery, London (2014); and the Chisenhale
Gallery (2012). An anthology of his texts, *A Primer for
Cadavers*, was published by Fitzcarraldo Editions in 2016,
and an extensive monograph was published by Skira
in 2017. In early 2019 he will have exhibitions at K21,
Düsseldorf, and Kunsthaus Bregenz. A novel, *Old Food*,

will be published in November 2019. He is currently
a guest professor at the Royal Danish Academy of Fine
Arts, Copenhagen.

Daniel Birnbaum (*1963) is a Swedish art critic, theoreti-
cian, curator, and director of the VR/AR art-production
platform Acute Art. He was the director of Moderna
Museet in Stockholm (2010–18) and the Städelschule and
Kunsthalle Portikus in Frankfurt am Main (2000–2010).
He cocurated the 50th Venice Biennale in 2003 and
served as director of the 53rd Venice Biennale in 2009.

Stefano Boeri (*1956) is a Milan-based architect. He is the
president of the Triennale di Milano, and was the Coun-
cillor for Culture for the Municipality of Milan (2011–13).
He is the founder of the international research network
Multiplicity and was editor in chief of *Domus* and *Abitare*
magazines. His studio Stefano Boeri Architetti's projects
in urbanism and contemporary architecture include the
Vertical Forest in Milan; Villa Méditerranée, on the
Marseille waterfront; and ex arsenal la maddalena, the
renovation of the ex-military port near the town of
La Maddalena, Sardinia.

Sophie Collins (*1989) grew up in North Holland, Nether-
lands, and now lives in Edinburgh. She won an Eric Gregory
Award for her poetry in 2014. *Small white monkeys,* a text
on self-expression and shame, was published by Book
Works in 2017. Her first poetry collection, *Who Is Mary
Sue?,* was published by Faber & Faber in 2018. She is
a lecturer at the University of Glasgow.

Douglas Coupland (*1961) is a Canadian writer and artist.
He has had solo shows at the Vancouver Art Gallery,
Museum of Contemporary Art Toronto, and Royal Ontario
Museum. His most recent exhibition, titled "Bit Rot,"
was shown at the Witte de With Center for Contemporary
Art in Rotterdam in 2015–16 and at Villa Stuck in
Munich in 2016–17.

Cui Jie (*1983) lives and works in Beijing and Shanghai. Her works have been included in many exhibitions, including "Past Skin" (2017) at MoMA PS1, New York; "The New Normal: China, Art, and 2017" (2017) at Ullens Center for Contemporary Art, Beijing; "HACK SPACE" (2016) at K11 Art Foundation, Hong Kong; and "Cui Jie: The Proposals for Old and New Urbanism" (2014) and "Cui Jie" (2012), both at Leo Xu Projects, Shanghai.

Manthia Diawara (*1953) is a writer, cultural theorist, film director, and scholar born in Bamako, Mali, and now based in the United States. He is professor of comparative literature and cinema at New York University.

Michael Diers (*1950) was professor of art history and visual studies at the University of Fine Arts in Hamburg and professor of art history at Humboldt University in Berlin until 2017. His publications include *Warburg aus Briefen: Kommentare zu den Kopierbüchern der Jahre 1905–1918* (1991); *Schlagbilder: Zur politischen Ikonographie der Gegenwart* (1997); *Fotografie, Film, Video: Beiträge zu einer kritischen Theorie des Bildes* (2006); as coeditor, *Das Interview: Formen und Foren des Künstlergesprächs* (2013), and *Vor aller Augen: Studien zu Kunst, Bild und Politik* (2016). He is a freelance writer for the newspapers *Frankfurter Allgemeine Zeitung*, *Süddeutsche Zeitung*, and *Neue Zürcher Zeitung*.

Andrew Durbin (*1989) is the author of *Mature Themes* (2014) and *MacArthur Park* (2017). He is the US senior editor of *frieze* and lives in New York.

Jimmie Durham (*1940) is a artist, poet, and writer who currently lives in Europe. He began his art practice in the 1960s and studied art at the École des beaux-arts in Geneva. Durham has taken part in numerous international exhibitions, such as documenta (1992, 2012), the Whitney Biennial (1993, 2003, 2014), the Venice Biennale (1999, 2001, 2003, 2005, 2013), the Istanbul Biennial

(1997, 2013) and many other group shows. He is the recipient of the 2016 Goslarer Kaiserring and the 2017 Robert Rauschenberg Award.

Monir Shahroudy Farmanfarmaian's (1924–2019) distinguished career spanned more than six decades, incorporating traditional reverse glass painting, mirror mosaics, and principles of Islamic geometry with a modern sensibility. She was the first Iranian artist to have a solo exhibition at the Solomon R. Guggenheim Museum in New York. The Monir Museum, the first museum in Iran dedicated to a single artist's work, opened in 2018 under the auspices of Tehran University.

Simone Fattal (*1942) was born in Damascus and grew up in Lebanon. After studying philosophy in Paris, she returned to Beirut and embarked on a career as a painter. In 1980, fleeing the civil war, she settled in California and founded the Post-Apollo Press, a publishing house dedicated to innovative and experimental literary works. In the summer of 2017, she had a retrospective at the Rochechouart Departmental Museum of Contemporary Art in the Château de Rochechouart in France, featuring all aspects of her work: painting, sculpture, collage, and film.

Dominique Gonzalez-Foerster (*1965) is an artist living in Paris and Rio de Janeiro. Recent solo exhibitions include "Tales of the 21st Century" at Galerie für Zeitgenössische Kunst, Leipzig (2018); "Pynchon Park" at MAAT, Lisbon (2017); "1887–2058" at the Centre Pompidou, Paris, and K.20, Düsseldorf (2015–16); and "Splendide Hotel" at the Palacio de Cristal at the Museo Reina Sofía, Madrid (2014).

Giorgio Griffa (*1936) was born in Turin, where he lives and works. His paintings follow a series of abstract paths of lines, fields, signs, numbers, and quotes painted with bright or delicate acrylics on raw unframed canvas nailed

directly to the wall along their top edge. When not exhibited, the works are folded and stacked, resulting in creases that become part of his compositions. Since 1968 he has been exhibited internationally, and has authored books and texts that uncover his ideas on art and its relations to science and philosophy.

Joseph Grigely (*1956) is an artist and writer whose work emphasizes archives and archival practices. Since 1995 he has worked with Hans Ulrich Obrist on over twenty exhibitions and publication projects, and since 1997 he has maintained Obrist's archive of printed media. Grigely's books include *Textualterity: Art, Theory, and Textual Criticism* (1995), *Conversation Pieces* (1998), *Exhibition Prosthetics* (2010), *MacLean 705* (2015), and *Oceans of Love: The Uncontainable Gregory Battcock* (2016). Grigley is professor of visual and critical studies at the School of the Art Institute of Chicago.

Boris Groys (*1947) is a philosopher, essayist, and art critic. He is a Global Distinguished Professor of Russian and Slavic Studies at New York University, senior research fellow at the Staatliche Hochschule für Gestaltung Karlsruhe, and professor of philosophy at the European Graduate School (EGS).

Jacques Herzog (*1950) cofounded the architecture practice Herzog & de Meuron with Pierre de Meuron in 1978. The practice been awarded numerous prizes, including the Pritzker Architecture Prize in 2001, and the RIBA Royal Gold Medal and the Praemium Imperiale, both in 2007. In 2014, Herzog & de Meuron were awarded the Mies Crown Hall Americas Prize for 1111 Lincoln Road, Miami Beach.

Ho Rui An (*1990) is an artist and writer. He writes, talks, and thinks around images, with an interest in investigating their emergence, transmission, and disappearance within contexts of globalism and governance. His recent projects were presented at the Jakarta Biennale (2017),

Biographies

Sharjah Biennial 13 (2017), Haus de Kulturen der Welt,
Berlin (2017), NTU Centre for Contemporary Art
Singapore (2017), and Kochi-Muziris Biennale (2014).

Jamian Juliano-Villani (*1987) lives and works in Brooklyn,
New York. Recent solo exhibitions include "Sincerely,
Tony," Massimo De Carlo, Milan (2017); "The World's
Greatest Planet on Earth," Studio Voltaire, London
(2016); "Detroit Affinities," Museum of Contemporary
Art Detroit (2015); and "Crypod," JTT, New York (2015).
Recent group shows include "A Shape That Stands Up,"
Hammer Museum (Off-Site), Los Angeles (2016); "FADE
IN: INT. ART GALLERY – DAY," Swiss Institute, New York
(2016); "Flatlands," Whitney Museum of American Art,
New York (2016); "Unorthodox," Jewish Museum, New
York (2015); and "Greater New York," MoMA PS1,
New York (2015).

Alex Katz (*1927) is one of the most recognized and
widely exhibited artists of his generation. Katz began
exhibiting his work in 1954, and since then he has pro-
duced a celebrated body of work that includes paintings,
drawings, sculptures, and prints. His work has been the
subject of more than two hundred solo exhibitions and
nearly five hundred group exhibitions around the world,
and can be found in nearly one hundred public collec-
tions worldwide.

Koo Jeong A lives and works everywhere. She has been
working since the mid-1990s on the reinvention of
spaces with site-specific works. Her works frequently
include architectural elements, drawings, fiction,
poetry, publications, installations, sculptures, films,
audio works, and architecture projects. Koo's most recent
project is a series of glow-in-the-dark skate parks:
Otro, in collaboration with L'Escaut Architectures,
on Vassivière Island, France (2012); *Evertro*, for the
Liverpool Biennial (2015); and most recently *Arrogation*,
for the 32nd São Paulo Biennial (2016).

190

Bruno Latour (*1947) is a French sociologist and philosopher. He is one of the founders of actor-network theory. His recent publications include *Facing Gaia: Eight Lectures on the New Climatic Regime* (2017), *Où atterrir? Comment s'orienter en politique* (2017), *An Inquiry into Modes of Existence: An Anthropology of the Moderns* (2013), as well as the accompanying website, www.modesofexistence.org. He has curated several exhibitions, including "Reset Modernity!" (2016), at ZKM | Center for Art and Media, Karlsruhe, with Martin Guinard-Terrin, Christophe Leclercq, and Donato Ricci.

Sophia Al-Maria (*1983) is an artist with deep reservations about the vocation.

D. T. Max (*1961) is a staff writer at the *New Yorker*. He is the author of *The Family That Couldn't Sleep: Unraveling a Venetian Medical Mystery* (2006) and *Every Love Story Is a Ghost Story: A Life of David Foster Wallace* (2012).

Yoko Ono (*1933) is an award-winning multimedia artist and peace activist. Her seminal performance art in the early 1960s, experimental films and collaborative music with John Lennon in the 1970s, and international one-woman shows and retrospectives from the 1980s to the present illustrate her varied career. Awards include two Grammys (1982 and 2001), the Venice Biennale's Golden Lion for Lifetime Achievement in 2009, the Hiroshima Art Prize in 2011, and the Oskar Kokoschka Prize in 2012.

Alan Pauls (*1959) is a writer based in Buenos Aires. He is the author of the novels *The Past* (2007) and *History of Money* (2015), and the essay "El factor Borges" (2004), among others.

Raqs Media Collective is Monica Narula, Jeebesh Bagchi, and Shuddhabrata Sengupta. Founded in 1992 in Delhi, they make contemporary art, edit books, curate exhibitions, and stage situations.

Biographies

Gerhard Richter (*1932) was born in Dresden, where he attended the Hochschule für Bildende Künste from 1951 to 1956. He fled to West Germany in 1961 and studied at the Kunstakademie in Düsseldorf from 1961 to 1964, where he held a professorship from 1971 until 1994. Richter has been the recipient of numerous distinguished awards, including the Oskar Kokoschka Prize in 1985, Goslarer Kaiserring in 1988, Japan's Praemium Imperiale in 1997, Golden Lion of the 47th Venice Biennale in 1997, and the Northrhein-Westfalia State Prize in 2000. Recent solo exhibitions include Foundation Beyeler, Basel; Museum Ludwig, Cologne; Tate Modern, London; Neue National-galerie, Berlin; and Centre Pompidou, Paris.

Torbjørn Rødland (*1970) is an artist living and working in Los Angeles and Oslo.

Adrián Villar Rojas (*1980) was born in Rosario, Argentina, and lives and works nomadically. Solo exhibitions include "The Theater of Disappearance," Geffen Contemporary at MOCA, Los Angeles (2017); NEON Foundation at Athens National Observatory (2017); Kunsthaus Bregenz (2017); Metropolitan Museum of Art, New York (2017). His most recent international group exhibitions include the 12th Havana Biennial (2015); Sharjah Biennial 12 (2015); Istanbul Biennial (2015); and dOCUMENTA (13) (2012). He represented Argentina at the 54th Venice Biennale (2011).

Pascale Marthine Tayou (*1966) lives and works in Ghent, Belgium, and Yaoundé, Cameroon. He has contributed to a number of major international exhibitions and art events, such as documenta 11 (2002) and the Venice Biennale (2005 and 2009). He had had solo shows at MACRO, Rome (2004 and 2013); S.M.A.K., Ghent (2004); Malmö Konsthall (2010); Kunsthaus Bregenz (2014); Fowler Museum, Los Angeles (2014); Musée de l'Homme, Paris (2015); Serpentine Sackler Gallery, London (2015); BOZAR, Brussels (2015); and Bass Museum, Miami (2018).

Adam Thirlwell (*1978) is the author of three novels, *Politics* (2003), *The Escape* (2009), and *Lurid & Cute* (2015); the novella *Kapow!* (2012); and a project on international fiction that includes an essay-book and a compendium of translations edited for McSweeney's. His work has been translated into thirty languages.

Agnès Varda (1928–2019) was a Belgian photographer and filmmaker widely associated with the French New Wave. Her films include *La Pointe Courte* (1955), *Cleo de 5 à 7* (1962), and *Les plages d'Agnès* (2008). She received lifetime achievement awards from the European Film Academy in 2014 and the Cannes Film Festival in 2010, as well as an honorary Palme d'Or in 2015 and an Academy Honorary Award in 2018.

Wong Hoy Cheong (*1960) is a visual artist and an occasional writer and curator based in George Town and Kuala Lumpur in Malaysia.

Colophon

An Exhibition Always Hides Another Exhibition
Texts on Hans Ulrich Obrist

Publisher: Sternberg Press
Editor: April Lamm
Copyeditor: Zoë Harris
Proofreading: Isabella Ritchie
Graphic Design: Zak Group
Typeface: Larish Neue by Radim Peško
Printing: GGP Media GmbH, Pössneck

© 2019 the artists, the authors, Hans Ulrich Obrist,
Sternberg Press
Portraits by Alex Katz (cover), Giorgio Griffa,
and Pascale Marthine Tayou © VG Bild-Kunst,
Bonn 2018. Tayou's work courtesy of Galleria Continua.
All rights reserved, including the right of reproduction
in whole or in part in any form.

ISBN 978-3-95679-288-5

Distributed by The MIT Press, Art Data,
and Les presses du réel

Sternberg Press
Caroline Schneider
Karl-Marx-Allee 78
D-10243 Berlin
www.sternberg-press.com

A Note on the Type
The interfinity mark (⸮) used in this book can
be described as an interrogative punctuation
mark formed by superimposing a vertical
infinity mark (∞) with a question mark (?).
The interfinity mark differs from the
short-lived percontation point, invented in the
late sixteenth century to indicate rhetorical
questions, in that it denotes ever-lasting and
ever-occurring questions. An interfinity
question is a question that has both an infinite
number of answers and no answer at all.

194